IMAGES
of America

BLACK MOUNTAIN COLLEGE

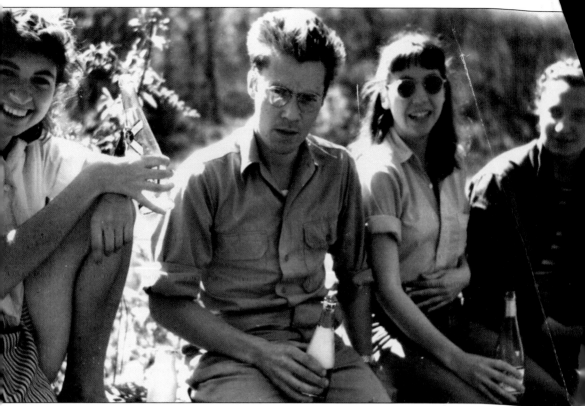

This photograph, taken by Stuart Atkinson, shows, from left to right, Black Mountain College students Beatrice "Bea" Myers, Olavi "Oli" Shivonen, Patricia "Patsy" Lynch, and Lorna Blaine Howard enjoying sodas on the Lake Eden Campus. (Courtesy of the State Archives of North Carolina, Western Regional Archives.)

ON THE COVER: Miriam "Mimi" French was a student at Black Mountain College from 1939 until 1944. She is pictured here in the weaving room working to secure her warp. (Courtesy of the State Archives of North Carolina, Western Regional Archives.)

IMAGES
of America

BLACK MOUNTAIN
COLLEGE

Anne Chesky Smith and Heather South

ARCADIA
PUBLISHING

Published by Arcadia Publishing
Charleston, South Carolina

Printed in the United States of America

Library of Congress Control Number: 2014932632

For all general information, please contact Arcadia Publishing:
Telephone 843-853-2070
Fax 843-853-0044
E-mail sales@arcadiapublishing.com
For customer service and orders:
Toll-Free 1-888-313-2665

Visit us on the Internet at www.arcadiapublishing.com

*To the memory and legacy of Black Mountain College
that continues to captivate and fascinate us.*

CONTENTS

Acknowledgments 6

Introduction 7

1. Founding a College 11

2. Blue Ridge Assembly 23

3. Building a Campus 47

4. Lake Eden 73

5. The End and the Beginning 111

Bibliography 126

About the Organizations 127

ACKNOWLEDGMENTS

Many thanks to the North Carolina Department of Cultural Resources (NCDCR) for generously allowing us to showcase their extensive Black Mountain College photograph collection in this book.

Anne wishes to thank the staff and board of the Swannanoa Valley Museum, especially John Corkran, son of Black Mountain College history and English professor David H. Corkran, who grew up on the Lake Eden campus from 1944 to 1950 and shared his time, expertise, and memories with her. Also, thanks to Ryan for getting her coffee (and just generally being great).

Heather would like to say a special thanks to her parents, Curtis and Lawana South, and sister Amber South for their continuous support of her historical endeavors. From driving on dirt roads to find a battle site to dusting the archives stack shelves, y'all help make all her history-nerd ambitions possible.

Unless otherwise noted, all images appear courtesy of the State Archives of North Carolina, Western Regional Archives.

INTRODUCTION

In the spring of 1933, John Andrew Rice, a classics professor at Rollins College in Winter Park, Florida, faced an investigating team to answer to charges that ranged from wearing a jockstrap on the beach to being "disruptive of peace and harmony." Denying the former charge but unable to fully dispute the latter because of his unconventional teaching methods and sometimes abrasive personality, Rice was fired. Several other faculty, including physics instructor Theodore Dreier, chemistry professor Frederick Georgia, and history professor Robert Lounsbury, rallied around Rice and the issues his firing brought up at the school. A few were also fired, and others resigned in protest.

That summer, many of Rice's former students and colleagues encouraged him to start a new experimental school where they could practice many of the educational theories of which Rice had often spoken. When he finally agreed, space for the college and money to operate it had to be found quickly. Former Rollins drama professor and native North Carolinian Bob Wunsch suggested Blue Ridge Assembly, located in Black Mountain, North Carolina.

The Christian conference center, in use only during the summer, proved to be an excellent location for the school. The large, three-story, white-columned main building, Robert E. Lee Hall, boasted a large lobby, wide porch, two wings, and rooms suitable for dorms. There was also a separate dining room directly behind Robert E. Lee Hall. All of this would well serve the college's idea of a communal living environmental. And, best of all, it was available for just $4,500 a year—a modest sum for a rental but still an obstacle for Rice and his supporters to raise before the start of the term.

Without a clear operational plan, Rice had trouble finding funding from traditional sources, but at the last minute, he lucked into a $10,000 gift from the wealthy family of another former Rollins faculty, "Mac" Forbes, who would continue to generously support the college for many years. Now, with enough money in the bank, Rice signed the lease for Blue Ridge Assembly on August 24, 1933, and Black Mountain College became a reality.

The first board of fellows consisted of Rice, Georgia, Lounsbury, Dreier, Dreier's younger brother John, and J.E. Spurr. When Lounsbury died suddenly of a stroke just after the start of the first term, and with John Dreier and Spurr mostly absent from the campus, the college was put firmly in the hands of three men—John Andrew Rice, Theodore Dreier, and Frederick Georgia. They appointed themselves to faculty positions, put together bylaws of the college, and elected Georgia as the college's first rector. After the first year, however, the title would be given to Rice.

But by no means was work in class and on campus the only, or even the main, emphasis of the college. Allowing time for leisure and personal exploration was another component of educating the whole student. The grounds and forests surrounding Blue Ridge Assembly allowed for an abundance of outdoor activities. Students and faculty gathered for dancing after dinner during the week and attended concerts and plays put on by the community on weekends.

The most innovative—and best remembered—part of Black Mountain's education experiment, though, was the school's emphasis on putting art at the center of the curriculum. Students were

encouraged to take courses in theater, music, drawing, painting, and poetry. But in order for the arts to be a central focus, an art teacher had to be found. After turning down several recommendations, Rice was told about a German couple that was trying to come to the United States after the Bauhaus had closed its doors. He hired Josef Albers, a painter, and his wife, Anni, a weaver, on the spot, sight unseen. The Albers arrived at Black Mountain just before Thanksgiving 1933 and would, for the next decade and a half, be a driving force behind the arts at the college. Over the years, more refugee artists would find haven at Black Mountain, greatly shaping the school.

Money was always an issue for the college, and when the college disbanded every April, no one really knew if it would reopen the next fall. Of the first 22 students, 14 came from Rollins. Only one, Gary McGraw, came from the local community; most others were from the Northeast. The question of admission standards soon came up. Would Black Mountain accept anyone who wanted to come? The answer to that quickly became "no," as some parents would attempt to ship their problem children off to the college. Tuition was kept low, but even so, many still struggled to afford it.

Unfortunately, those with money were often not the most desirable students. The college, however, had to find a balance in order to operate. Interviews were required, and some students were rejected outright. With such a small student body (that would grow to just 55 by the fall of 1936), the board could not afford to pay the instructors they hired (Albers was the only exception), but they did offer free room and board within Robert E. Lee Hall, which was divided into one wing for faculty and another for students. Ted Dreier, as treasurer for the next 15 years, spent much of his time traveling the country searching for donations of any size to maintain the college, and his efforts allowed Black Mountain to survive for many years.

The college would gain notoriety during the 1930s, appearing in newspaper articles and attracting visitors such as John Dewey, Thornton Wilder, Henry Miller, and Aldous Huxley, who were interested in the Black Mountain experiment. But when Louis Adamic, a Yugoslavian writer, came to Black Mountain in 1936 and wrote a long magazine article that would appear in *Harper's* and *Reader's Digest*, a schism in the community began to develop. Though the article, brought the college much-needed publicity, it presented John Andrew Rice as the hero and leader of the school, a view to which many objected loudly and publicly. The fight between Rice and his detractors continued for over a year, and many faculty who were against him—including Frederick Georgia—were forced out. In 1938, however, it was discovered that Rice was having an affair with a student and that became the precipitating factor that finally forced him from Black Mountain in 1940. His exit, along with a change of campus, would successfully bring about the end of the first era in Black Mountain College's history.

While Blue Ridge Assembly served the college well during its first years, moving in and out every summer to make room for the Christian conference goers became problematic. Plus, renting a facility limited how much the college could grow and change. So in 1937, the college purchased a 667-acre property across the valley at Lake Eden. The property had originally been developed by E.W. Grove, the pharmaceutical magnate who built the Grove Park Inn and the Grove Arcade in Asheville, as a summer resort for his nearby planned community of Grovemont. Grove had constructed two large lodges, a dining hall with a large porch that overlooked Lake Eden, and several other small cottages, using rock as a primary material (as was his style).

The founder of the Bauhaus, Walter Gropius, was commissioned to design the new building, but when his design of several connected structures was determined to cost too much for the college to raise during the war, architecture professor A. Lawrence Kocher was asked to design a single facility that would house classrooms, space for a weaving room, storage, student studies, and faculty apartments. The design was approved, and beginning in the fall of 1940, in an effort to save money, classes were only held in the morning so that students and faculty could go to Lake Eden and work with a few professionals on winterizing the existing structures and constructing the new Studies Building.

In May 1941, with the end of their lease at Blue Ridge Assembly, the college packed up all their equipment and trucked it to the Lake Eden property, which still required quite a bit of work to

get ready for the fall term and was still not finished by the end of the year. For some that had grown used to living and working in one building—Robert E. Lee Hall—at Blue Ridge Assembly, the change to Lake Eden, where distance separated much of the community from one another, was unwelcome. However, for the large majority, creating a space designed specifically for the college was exciting.

But just as the college was getting settled in its new home, the United States entered World War II, and the future of Black Mountain began to once again seem nebulous. As most male students were drafted, the college community during the war years consisted mostly of refugees, those too old to serve, and women. Almost all the money that came in went to the building program. Faculty salaries went unpaid, and the school took out a second mortgage on its property. Still, the college soldiered on. It expanded its farm program to provide for more of the community's needs and began to mine mica on the property to raise funds.

Near the end of the war, the race issue was broached. The students voted 2-1 to admit black students as full members of the college. The faculty, however, was split. Though most students and faculty felt that not admitting black students would conflict with the ideals of the college community, many were still cautious. Though it was noted that the college would probably receive greater funding if it were to admit black students—including $2,000 promised from the Rosenwald Fund, there was fear of backlash from the community, including violence, arson, and boycotts. Throughout its history, Black Mountain College had a tumultuous relationship with the local community. Often, students would travel into town wearing shorts and with bare feet, starting rumors about that the school was a haven for free love, nudists, and Communists. It was feared that any move to integrate Black Mountain might be the last straw for the surrounding community.

Caution, for the most part, won out, and only a single black woman, Alma Stone, was invited to attend the 1944 Summer Institute. Over the next few years, other black students and faculty—Carol Brice, Roland Hayes, Percy H. Baker, and Jacob Lawrence, to name a few—were invited to attend. The college was fully integrated by 1947, seven years before it was legally mandated, though after the initial push, few black students would choose to attend Black Mountain.

Like the 1930s, the 1940s brought new faculty, new ideas, and new schisms within the college. The same summer (1944) in which the college invited Alma Stone to be the first black member of the community also saw the introduction of two special summer sessions—one in art and one in music—that, over the years, would bring many notable artists, including Willem de Kooning, John Cage, Merce Cunningham, Beaumont and Nancy Newhall, and Buckminster Fuller, to teach at Black Mountain for a few weeks. It was during one of these summer sessions that Fuller would successfully erect his first geodesic dome.

By 1945, enrollment was at 60 students, and though still only 25 percent male, the GI Bill of Rights was approved for Black Mountain in English, social science, chemistry, mathematics, and music and would be critical to the survival of the college after the war. The Black Mountain experience proved appealing to many young men returning from war, and enrollment would climb to over 90 students (more than 50 percent male) by 1947. Among these students were many struggling artists, some of whom—Arthur Penn, Robert Rauschenberg, Ruth Asawa, and Kenneth Noland, to name a few—would become very well known.

But as the GI Bill began to run out and Albers, as rector, attempted to restructure the school to focus less on liberal arts and more on arts and music, enrollment dropped back down to 50 students. The school was plagued with money troubles as well as conflict between many of the newer faculty and the old, faithful contingent that had served the school since its inception—Ted Dreier and Josef and Anni Albers. Afraid that Dreier might try to close the school to avoid further loss of income (among other things), panicked faculty asked for his resignation. The Alberses resigned in protest, bringing Black Mountain's second era to a close and leaving the college with only one of the original 1933 group remaining: John Andrew Rice's wife, Nell.

Black Mountain's third, and final, era saw it become a dramatically different place than it had been for the first 16 years. Enrollment dropped even further in the 1950s, falling to 35 students by 1953, then to 15, then to 9, which kept funding a continuing issue. Selling a large tract of

land across the road from the college shored up some of the college's finances, but few at the school in the 1950s were interested (or nearly as good as Ted Dreier had been) in fundraising and administration. Interest in the work program was minimal. The farm was neglected, and when the cows began to die from lack of care, they were sold off. The few attempts on behalf of some faculty members to add a more traditional structure to the college failed in favor of continuing the college's original ideals of creativity, freedom, and artistic expression, and those faculty, frustrated with the direction in which the college was headed, left the school.

But the 1950s also saw some of the most notable and celebrated artists and art in the history of the college. For the first time, writing became an emphasis. Noted poet Charles Olson, who had taught during a late-1940s summer session, came back to the college and took over as rector. He recruited poets Robert Creeley and Robert Duncan to teach, and Creeley founded the *Black Mountain Review.* The 1950s saw the first "happening," a loosely structured, mixed-media performance created by composer John Cage. He and choreographer Merce Cunningham came back to the school for long periods throughout the 1950s to work on their own art and teach. Though the last of the college's summer sessions were held in 1953, Olson attempted to reorganize the structure of the school away from a traditional class schedule to a series of institutes in art, science, and social science held for intense periods throughout the semester.

But, in the end, it was not enough. The college was in debt, and the 1950s conservatism made it impossible to fundraise enough to sustain it. Forbes refused to continue funding the school and demanded repayment on his portion of the mortgage. Unable to afford coal to heat the school in the winter, the college suspended classes for three months. The kitchen shut down, and community members became very skilled at stealing food from the local A&P grocery store. In 1956, the college leased the main buildings to a Christian summer camp that would eventually buy the entire property. In the last few years, Olson tried in vain to come up with new ways to keep Black Mountain in operation, but finally, in the fall of 1956, the few remaining faculty asked Olson to close the school. In March 1957, Olson was court ordered to cease operations, signaling the end of Black Mountain College. Of the approximately 1,200 students that attended the school, only about 60 ever graduated, yet after being at Black Mountain, many would go on to attend top graduate schools and to develop promising careers in the arts, education, and other fields.

Though it only lasted 24 years, Black Mountain College continues to inspire thought on community living, experimental education, and the arts. Several books have already been compiled that chronicle the history of the place, the art that came out of it, and many of the personal stories from the college. The purpose of this publication is twofold—to showcase a small percentage of the image collection at the NCDCR and to introduce Black Mountain College to those who never knew this special place existed.

One

FOUNDING A COLLEGE

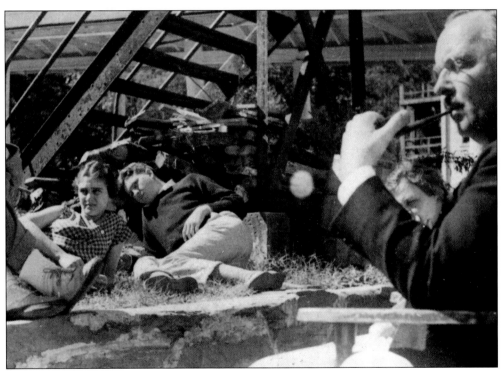

John Andrew Rice, after being fired from Rollins College, opened Black Mountain College at Blue Ridge Assembly just outside the village of Black Mountain in 1933 with 21 students (12 of whom had followed him and other faculty from Rollins) and a unique teaching philosophy that endures today. He made work and art part of every student's curriculum to help educate the full person—mind and body. Cultural event and community service requirements in colleges today are part of that same philosophy. In the photograph, he is pictured far right, smoking his pipe, while teaching a philosophy class behind Robert E. Lee Hall at Blue Ridge Assembly. Though Rice is often credited as being the first rector at Black Mountain, chemistry professor Frederick Georgia served a rector for the first year before quickly handing the position over to Rice.

American John Dewey (1859–1952) was a psychologist and philosopher whose principles of education were a major component of the educational philosophy at Black Mountain College. Dewey believed that education should be interactive and experiential and that it should encompass social reform. Teachers were meant to be facilitators of learning rather than lecturers.

Rollins College physics professor Theodore "Ted" Dreier was one of the four founders of Black Mountain College along with two other former Rollins colleagues who were dismissed at the same time as Rice—Ralph Lounsbury (who died shortly after the college was founded) and Frederick Georgia. Dreier was one of the strongest supporters of the college's work program and its most ardent fundraiser. Though the school was never flush with funds, its bank accounts dried up quickly after Dreier was forced out at the end of the 1940s.

The Black Mountain College faculty and staff are pictured here in September 1933 before the arrival of art professors Josef and Anni Albers, who would come in November. From left to right are (first row) Joseph Martin, Helen Boyden Lamb Lamont, Margaret Loram Bailey, Elizabeth Vogler, and John Andrew Rice; (second row) John Evarts, Theodore Dreier, Frederick Georgia, Ralph Lounsbury, and William Hinckley.

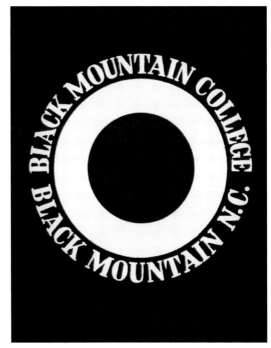

"As a symbol of union, we have chosen simply a simple ring. It is an emphasized ring to emphasize coming together, standing together, working together. Or, it is one circle within another: color and white, light and shadow, in balance," said Josef Albers of the Black Mountain College emblem, pictured here.

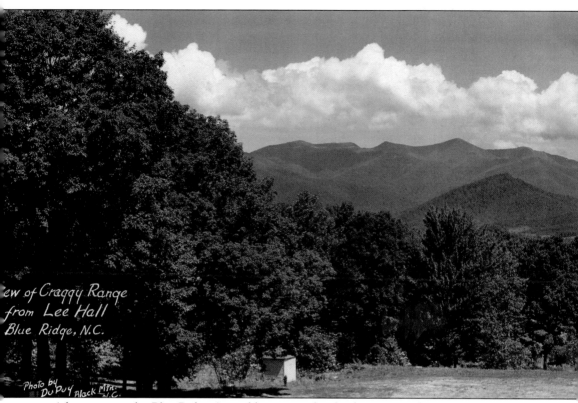

ew of Craggy Range
from Lee Hall
Blue Ridge, N.C.

Photo by
DuPuy Black Mtn.
N.C.

After viewing the Blue Ridge Assembly campus for the first time, John Andrew Rice wrote, "Perfect. Here was peace. Here was also central heating against the cold of winter, blankets, sheets, dishes, flatware, enough for a dozen colleges, all at a moderate rental." This panoramic photograph was taken from the front porch of Blue Ridge Assembly's main building, Robert E.

Lee Hall, by local photographer Edward DuPuy. The college would operate out of the assembly's grounds during the academic year for the next seven years, moving out every summer to make room for Christian retreats. (Courtesy of Swannanoa Valley Museum.)

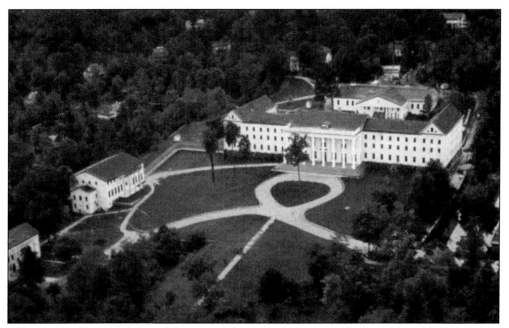

This historical postcard shows Blue Ridge Assembly from above. Robert E. Lee Hall, the main campus building and dormitory for students and staff, is in the center of the card. Also visible are the dining hall, located behind Robert E. Lee Hall, and the swimming pool to the right of Robert E. Lee Hall. Water for the pool was fed in from a mountain stream on the property. The 1,600-acre property was originally purchased in 1906 by Willis Weatherford for the YMCA to serve as a Christian summer-retreat center. (Courtesy of Swannanoa Valley Museum.)

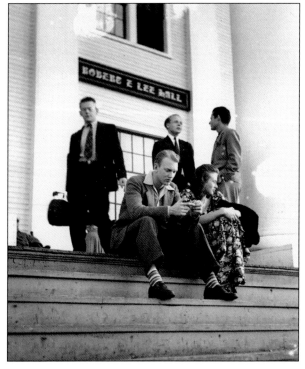

Black Mountain College student Maud Dabbs waits with another unidentified student for a ride on the steps of Robert E. Lee Hall in 1938. The building was the center of college operations while it occupied the Blue Ridge Assembly grounds. The photograph was taken by Robert Haas, Dabbs's future husband.

According to Martin Duberman in his book *Black Mountain: An Experiment in Education*, one student told him, "A favorite slogan at Black Mountain was that 'as much real education took place over the coffee cups as in the classroom.'" At left, the porch of Robert E. Lee Hall overlooked the Swannanoa Valley below and the Black Mountains to the north. The view made the area a popular place for class meetings, informal gatherings, and even dances. Below, a springtime photograph shows the walkway and parking lot in front of Robert E. Lee Hall. The building, designed by New York architect Louis Jallade, was constructed in 1912.

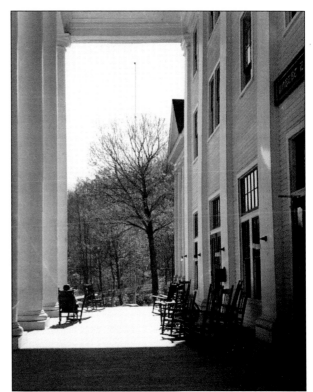

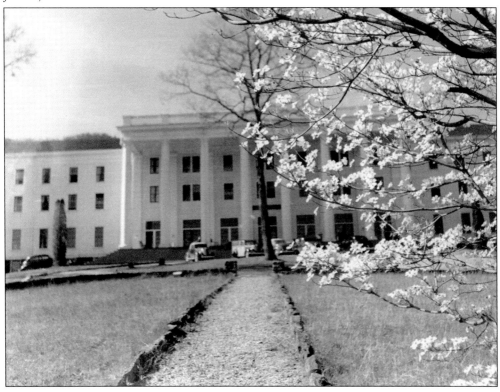

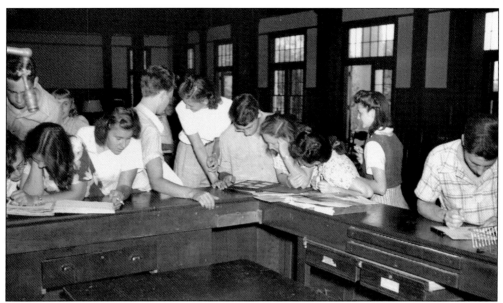

Students gather around the credenza in the lobby of Robert E. Lee Hall. The front door to the building leading out to the porch can be seen behind them. Student dorms and studies were located off the lobby in the right (or west) wing, while single faculty members had their bedrooms and studies in the left (or east) wing.

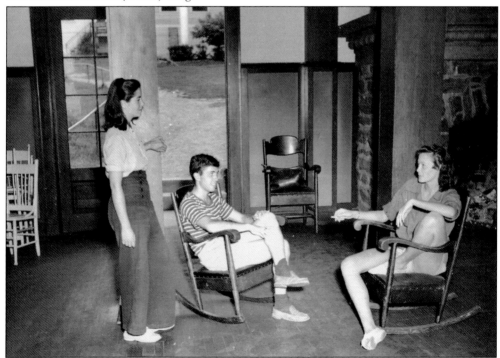

From left to right, students Mary Rose Riegger (Wallingford), an unidentified male student, and Connie Spencer chat near the back of the Robert E. Lee Hall lobby. The large lobby fireplace, as well as the door and walkway leading to the dining hall behind the building, can be seen in the photograph.

18

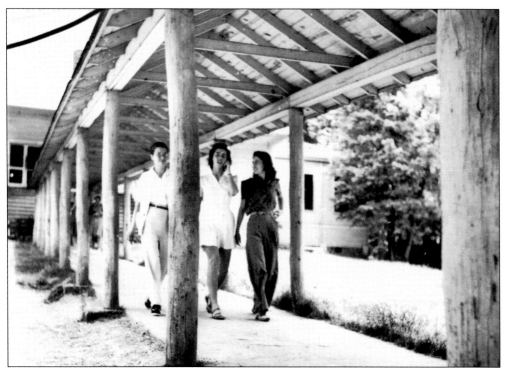

As was tradition at the time, Robert E. Lee Hall, the main building, was connected to the dining hall by a covered walkway in case of a kitchen fire. The dining hall was also used for dances and as a performance space. Pictured above are, from left to right, Mary Rose Riegger, Hyalie Yamins, and possibly Maud Dabbs strolling under the walkway joining Robert E. Lee Hall with the campus dining hall about 1939. Pictured in the historical postcard below is the Blue Ridge dining hall. (Below, courtesy of the Swannanoa Valley Museum.)

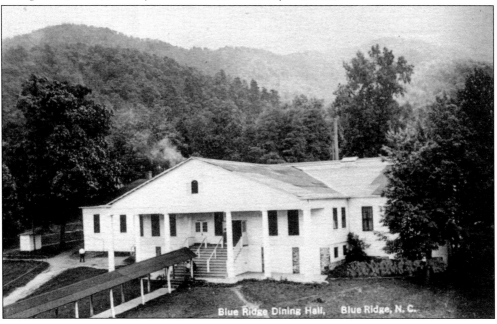

Blue Ridge Dining Hall, Blue Ridge, N. C.

"Don't ask me how or why I know it, but I know it: if I can't get the right man for art, then the thing won't work," John Andrew Rice said of his search for the college's first art professor. He found Josef Albers, and the thing worked. Albers was a well-known artist born in Germany in 1888 to a Roman Catholic family. He married Anni Fleischmann, born to Jewish parents, in 1925, and they both relocated to Black Mountain in November 1933 to escape Hitler's Nazi regime. Anni was an accomplished weaver and textile artist. They remained at Black Mountain until 1949, and Josef was head of the painting program, teaching students such as Ray Johnson, Robert Rauschenberg, Cy Twombly, and Susan Weil. In the Claude Stoller photograph above, Josef Albers kneels with Ted Dreier's son Eddie on the steps of Robert E. Lee Hall around 1940. Below, Anni threads a spindle.

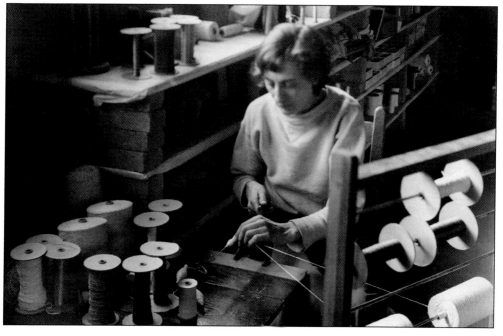

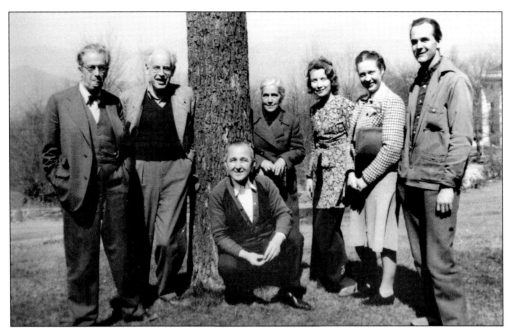

Black Mountain College never had a board of directors. The faculty owned the college and operated it with the input of students. Ted Dreier remembered, "We have said, we would not make any important decision affecting the students without consulting them." In the above 1930s faculty portrait on the Blue Ridge campus are, from left to right, Heinrich Jalowetz, Erwin Straus, Robert Wunsch (squatting), Johanna Jalowetz, Gertrude Straus, unidentified, and John Evarts. Below, Robert Wunsch, who was the college' rector from 1939 until 1945, holds a faculty committee meeting behind Robert E. Lee Hall. Pictured from left to right are Dr. Charlie Lindsley (chemistry), John Evarts (music), Robert Wunsch, Dr. Erwin Straus (psychology and philosophy), and Dr. Heinrich Jalowetz (music).

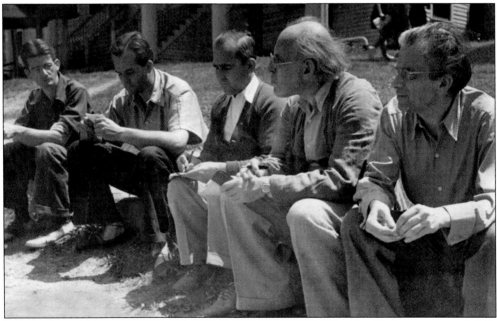

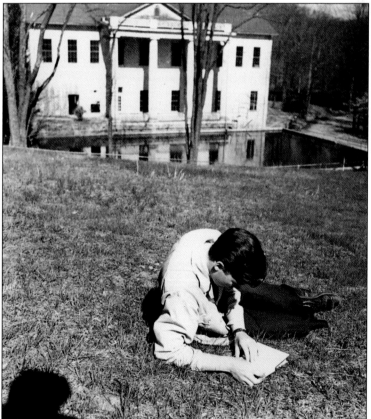

"There is only one first year to any institution, and it is doubtful any of us will ever quite recapture the mood of that first autumn," said English professor Joe Martin of the 1933–1934 academic year at Black Mountain College. Above, students and faculty take part in an outdoor meeting for the entire student body, a common occurrence at Blue Ridge Assembly. At left, a student, possibly Don Page, reads on the lawn beside the swimming pool and the gymnasium.

Two

BLUE RIDGE ASSEMBLY

A description written in the State Archives of North Carolina about its Black Mountain College collections reads, "The purpose of the college was to educate the whole person, with an emphasis on the role of the arts and creative thinking. Black Mountain College itself was owned by the faculty, with students playing a significant role in the decision making process." Here, unidentified students gather on the steps of Robert E. Lee Hall.

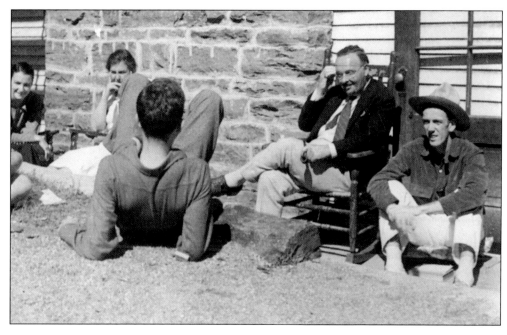

"You're seeing people under all circumstances daily, and after a while you get to the point where you don't mind being seen yourself, and that's a fine moment," John Andrew Rice said of the experience he hoped students would have at the college. Rice (seated in the rocking chair) and student David Bailey (in hat) are pictured above meeting with other students behind Robert E. Lee Hall. Below, Rice conducts a class in the lobby of Robert E. Lee Hall at the Blue Ridge Assembly campus.

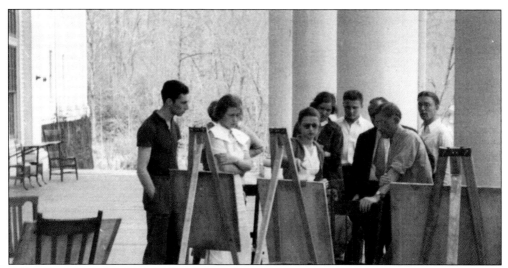

Of his decision to hire Josef Albers without first meeting him, John Andrew Rice said, "If you ever meet anybody who has seen a great teacher in action, something happens as soon as you mention his name. Something happens to the person that's talking to the person who's talking about him. You see a vision." After Rice heard Philip C. Johnson, a curator at the Museum of Modern Art in New York City, talk about Albers, he hired the artist on the spot. In the above photograph, taken by Anne Chapin Weston, Albers teaches an art class on the porch of Robert E. Lee Hall. John Andrew Rice is slightly obscured behind Albers. Below, Albers teaches a drawing class in one of the art classrooms at Blue Ridge. Student Ray Johnson sits in the first row; to his left is Hazel-Frieda Larsen.

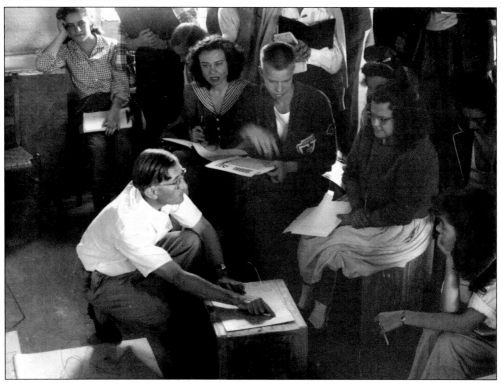

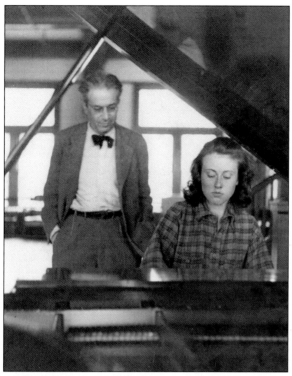

Conductor Heinrich Jalowetz, affectionately called "Jalo," immigrated to the United States from Austria with his wife, Johanna, in 1938 to teach at Black Mountain College. Student Emil Willimez remembered someone saying, "I would not have appreciated the visual world as much without Albers, and man's love for man without Jalowetz." Jalowetz died at Lake Eden in February 1946 and is buried on the Lake Eden property. Willimez said of him, "Jalowetz's death was very much in keeping with his life. He performed an evening of Beethoven sonatas, walked out on the porch, sat down and died. There is no doubt that he was the most beloved person at the college." At left, Jalowetz instructs student Maud Dabbs on piano. Below, he plays for a student rehearsal in a storage room at the school.

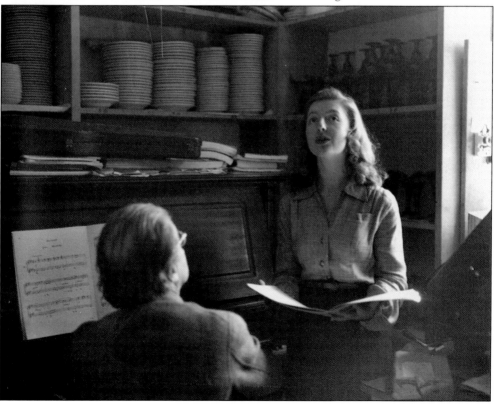

Robert "Bob" Wunsch, though he left Rollins College with Rice and others, did not come to Black Mountain until 1935. Wunsch, a native North Carolinian, did, however, lead Rice to find the Blue Ridge Assembly campus in 1933. At the college, Wunsch taught English and, more notably, drama. Here, he rehearses with student John Stix for a performance of *Macbeth* in May 1940 on the porch roof of Robert E. Lee Hall.

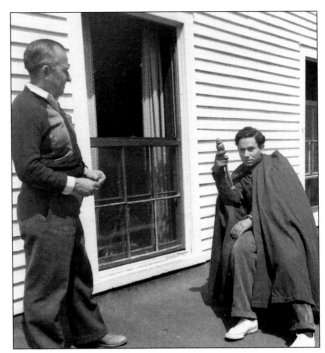

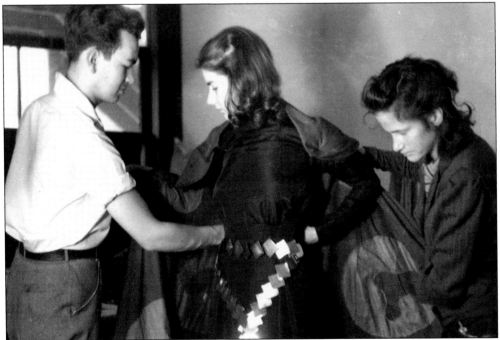

Student Will Hamlin remembered, "Theatre at Black Mountain was radically different. We performed with little or no scenery. Costumes for plays were imaginative but simple . . . We saw people from other colleges unload trucks full of scenery and racks of costumes. But we drove back with first prizes for acting, direction, and overall production." In this photograph, students George Randall (far left) and Lisa Jalowetz (far right) help Sue Spayth, who played Lady Macbeth, dress in the costume room before a college production of *Macbeth* in May 1940.

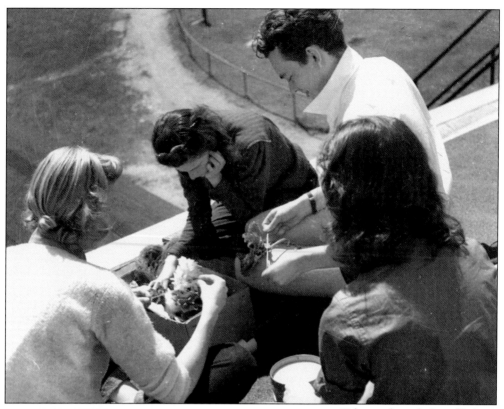

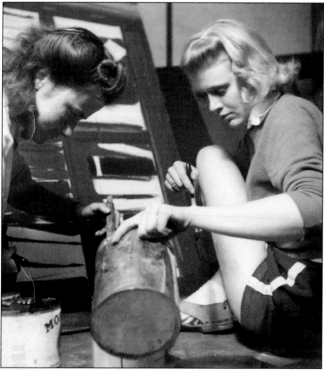

"I learned much from [Bob Wunsch], since he talked more openly about events and his feelings. Often late at night, after I had been with friends, I would go by his study and drop in to talk," remembered student Robert Sunley. In the photograph above, students work on costumes for a drama production in Wunsch's class around 1940. Pictured on the Robert E. Lee Hall roof porch are, from left to right, Barbara Sieck, Lisa Jalowetz, George Randall, and an unidentified student. At left, in a photograph taken by Robert Haas in the spring of 1940, students Barbara Sieck (left) and Lisa Jalowetz (right) paint a set for a production of *Ah, Wilderness!* by Eugene O'Neill.

One of the primary goals of Black Mountain College was to integrate the arts into education. The school offered courses in drama, painting, drawing, music, composition, and poetry, among many others. At right, students Martha Hunt and John Stix perform in the drama production *Macbeth* in May 1940. John Stix, who attended Black Mountain College from 1938 to 1942, was one of the few students to officially graduate from the college. Stix then went on to receive his master of fine arts from New York University and become a well-known film and stage director. Below, students perform in a 1938 production of *Bury the Dead* in this photograph by George Hendrickson, who was also the designer for the production. Rather than use a traditional stage, he designed sectional sets that surrounded the audience.

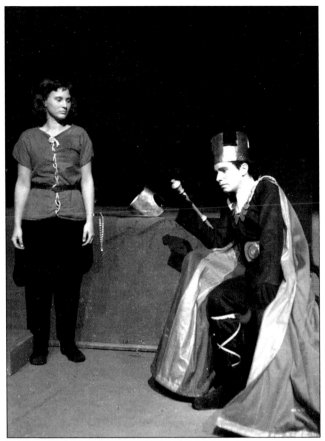

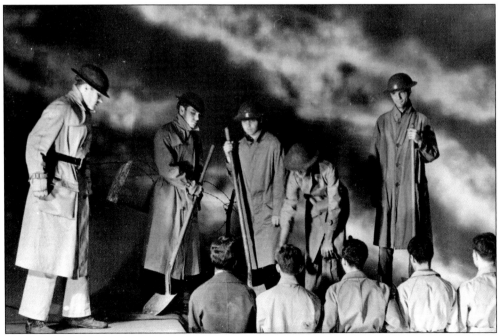

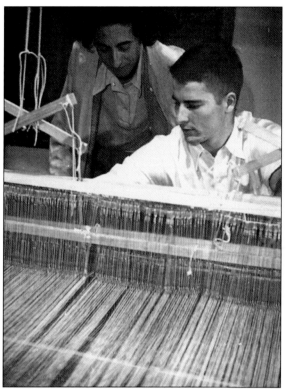

Speaking about her teaching method, Anni Albers said, "I tried to put my students at the point of zero. I tried to have them imagine, let's say, that they are in a desert in Peru, no clothing, no nothing, no pottery even at that time, and to imagine themselves at the beach with nothing . . . And it's hot and windy. So what do you do? You wear the skin of some kind of animal maybe to protect yourself from too much sun or maybe the wind occasionally. And you want a roof over something and so on. And how do you gradually come to realize what a textile can be? And we start at that point." In the photograph, Anni Albers works with a student at a college loom around 1938.

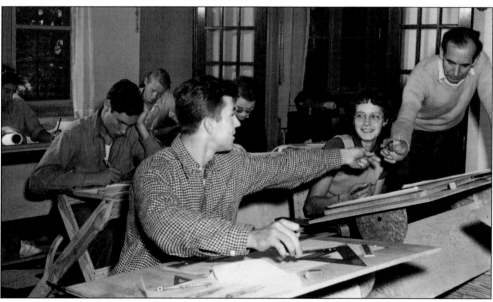

Black Mountain also offered beginning courses in architecture that were notable primarily because students were often involved in helping design and build structures for their own use. Prof. A. Lawrence Kocher had been interested in Black Mountain College since its beginnings but did not come to teach at the college until the fall of 1940, when they asked him to help design buildings for the new Lake Eden campus. Here, Kocher teaches an architecture class in the early 1940s on the Blue Ridge campus. Student Don Page hands him a pencil.

In the early years at the college, science was underrepresented, partly because the courses were not required and the students at the school, for the most part, did not see the need to study science. In the mid-1930s, the only science courses offered were physics (taught by Ted Dreier), chemistry (taught by Frederick Georgia), and biology (taught by Anna Moellenhoff). At right, a student, possibly Kathryn Sieck, peers through a microscope in an early college science course. Below, another unidentified student performs a chemistry experiment.

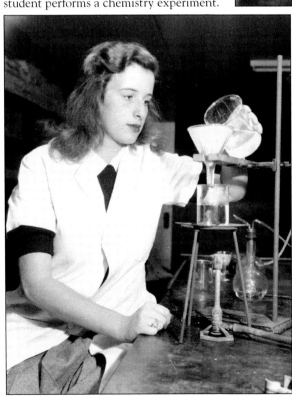

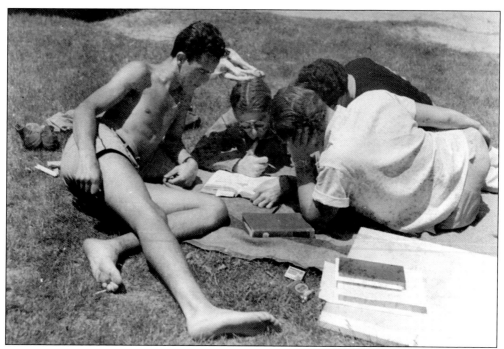

Charles Lindsley was invited to join the faculty at the college as a chemistry professor in 1938 after Frederick Georgia, one of the founders of the school and the former chemistry teacher, was forced out by Rice and others. Lindsley was appointed to serve as the chemistry instructor in the fall of 1939 and filled the position until 1942 when he took a position with the Department of Defense doing research for the War Department. He named Fritz Hansgirg, a German refugee who had been interned as an enemy alien, as his successor. In the above photograph, Lindsley's chemistry class meets on the lawn at Blue Ridge Assembly. Below, two unidentified students work in the college's chemistry lab.

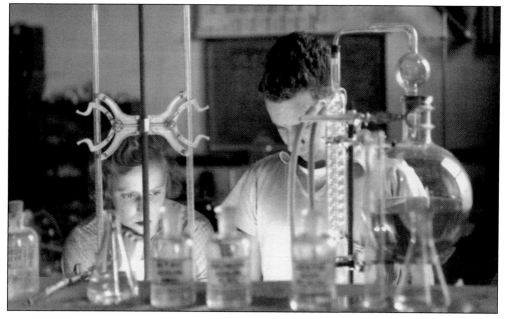

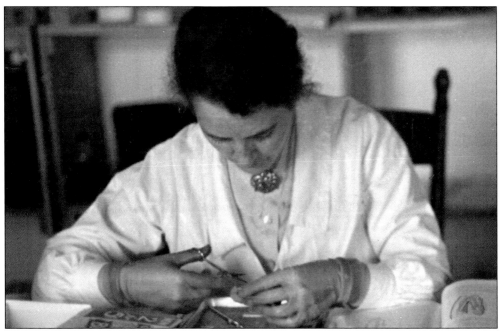

Anna Moellenhoff and husband Fritz, a psychoanalyst, came to Black Mountain College in 1935 from Germany on the suggestion of Josef Albers. Anna taught biology and German from 1935 until 1939. She left in 1939 when her husband got a job elsewhere. In 1940, the young biologist Richard Carpenter replaced her and taught biology courses until 1942, when he died from lung cancer at only 31 years old. Above, Anna Moellenhoff works in her biology lab dissecting a specimen. Below, Richard Carpenter (far right) works with two unidentified students to dissect a frog.

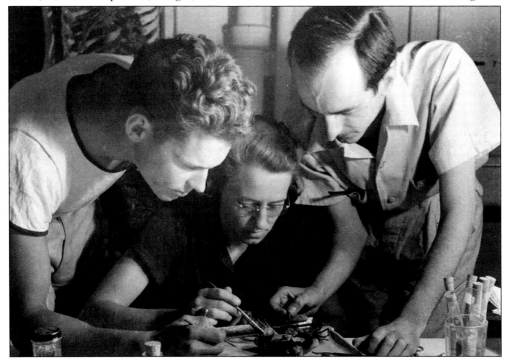

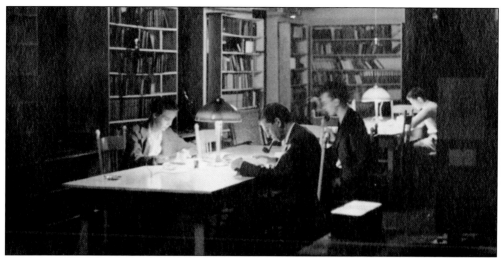

Though students shared dormitory rooms in Robert E. Lee Hall, they all had their own studies. Still, like most activities at the college, studying was often a communal activity. In the photograph above, several students gather in the library at night. The library, like the weaving studio, printing press, and the US Blue Ridge Post Office, was located in the basement of Robert E. Lee Hall. Students also set up a darkroom in the Robert E. Lee Hall basement. There was no photography instructor, but Josef Albers would critique student photographers. Below, Claude Stoller takes photographs of Barbara Sieck on the Blue Ridge campus. Stoller and Sieck were students at the college from 1939 until 1942. Though Stoller studied architecture at the college and would become an architect later in life, he pursued an interest in photography at the school.

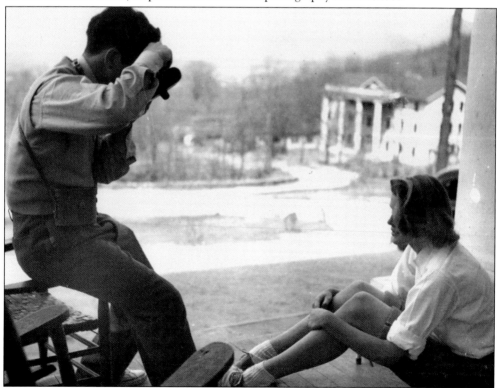

Above, Ted Dreier's son Eddie is pictured at far left. The long hallway leading to dorm rooms and studies can be seen behind Eddie. The mailboxes where students and faculty collected their mail line the wall of the lobby. Below, students catch up on the daily news in the lobby of Robert E. Lee Hall.

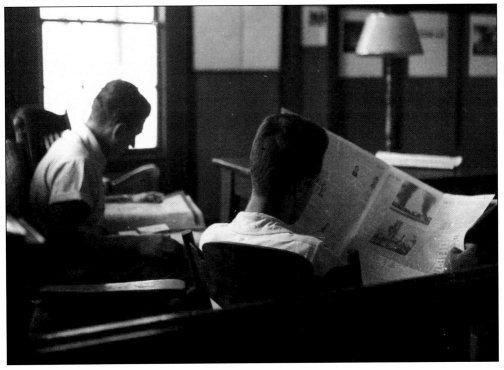

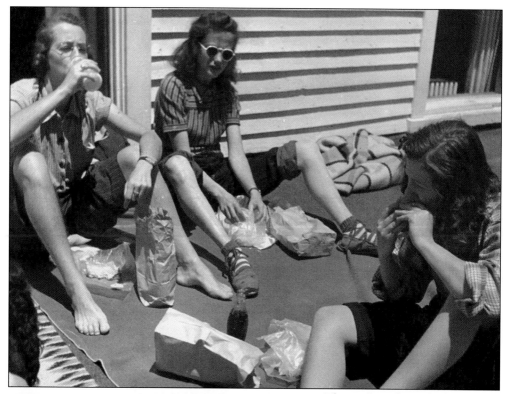

The roof porch on the back of Robert E. Lee Hall was a favorite spot at Blue Ridge Assembly for studying, snacking, sunbathing, or just hanging out. Above, three unidentified students eat lunch on blankets spread out for the occasion. At left, student Bill Reed studies on the rooftop. Bill Reed studied weaving with Anni Albers at the college and was one of the few students to graduate. He stayed on after graduation as an assistant to Josef Albers.

Mealtime at the college was generally a festive time of intellectual conversation and socialization. Diners served themselves and then bused their own tables, making a game of stacking as many cups and saucers on a tray as possible. A right, campus members soak up the sun while reading in the rocking chairs off the dining hall after a meal. Below, students and faculty eat together in the large dining room behind Robert E. Lee Hall around 1940.

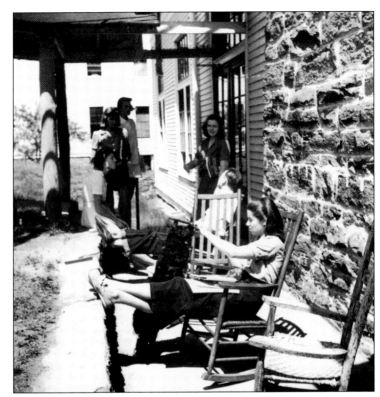

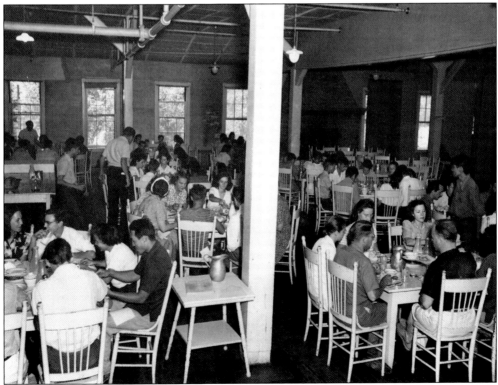

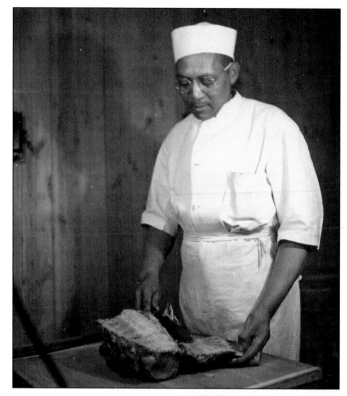

Jack Lipsey was the head cook at Black Mountain College, assisted by his wife, Rubye, and a couple of other kitchen workers. Rubye, an energetic college graduate, also served as an unofficial counselor for many of the girls at the school. Jack held the students to a standard and would refuse to serve anyone who was rude or dirty. At left, Jack Lipsey prepares a side of meat in the Blue Ridge kitchen. Below, Rubye Lipsey serves gravy.

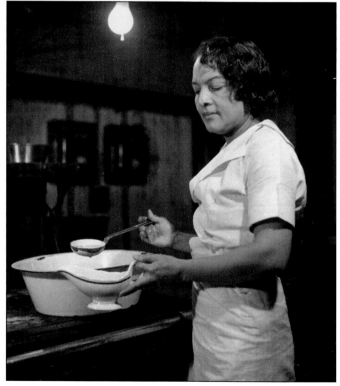

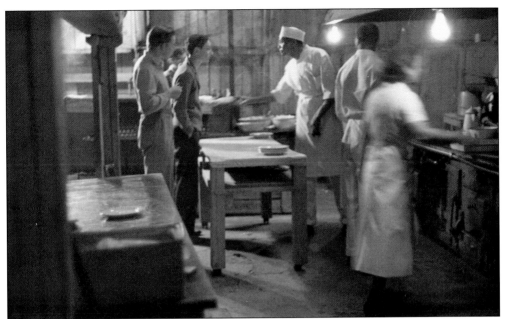

John Andrew Rice said that he could tell how Jack Lipsey felt about a person from the way that Jack handed them their plate. After Rice made the comment, several members of the community avoided getting their plates from the cook in front of others. In these photographs, taken by Helen Post Modley, Jack Lipsey (in hat) hands a plate to a student, while another kitchen worker and Rubye Lipsey (far right) are busy at the stove.

Though meals throughout the week were prepared for the school by a kitchen staff, on Sundays, the kitchen staff was given the day off, and a sandwich bar was left for faculty and students to partake of. This arrangement offered a great time for discussion amongst the college community in its early years. The dining hall became a classroom unlike any other. In the photograph, Bobbie Dreier prepares lunch.

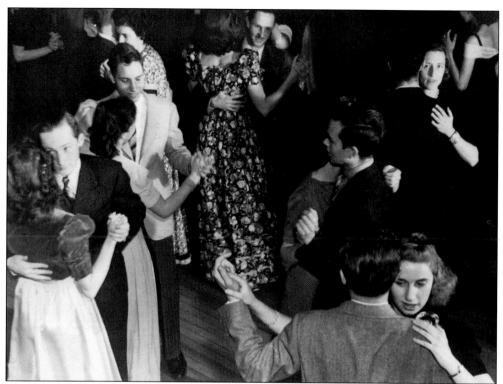

The dining hall at Blue Ridge was also used for after-dinner dances and as a performance space. Here, Kenneth Kurtz (back, center) dances with a partner in a flowered dress.

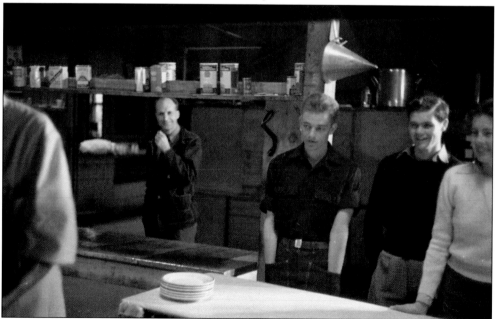

The college work program placed students in different tasks around campus, including in the kitchen. Here, Ted Dreier, who led the work program, stands in the kitchen at left, supervising several students as they observe Jack Lipsey at the stove.

"Ted had this notion having been born in Brooklyn Heights, and never having seen more than a few blades of grass, that there was some kind of mystical experience in touching the soil," John Andrew Rice said of Ted Dreier's love for the work program and manual labor. In the above photograph, Dreier stands in the center, leading a work program meeting. From left to right are three unidentified participants, Josef Albers (hands clasped with his back to camera), Erwin Straus, Robert Wunsch, Kenneth Kurtz (standing to the right), Fred Stone, and Eva Zhitlowsky. At right, students load up in a college truck to catch a ride to the farm.

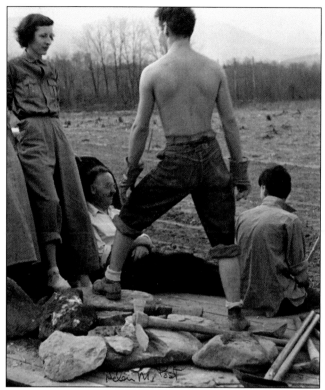

"If you want to work . . . fine, that's fine. Go ahead. I like it. But I don't want anybody else to do it if they don't want to . . . hell, if I was a violinist, I wouldn't want to handle bricks . . . I wouldn't want to imperil my hands. Certainly not," John Andrew Rice said of the work program. In the photograph at left, by Helen Post Modley, students rest on a farm truck with John Andrew Rice (seated against truck cab). Below, a student plows a field at the college's early farm in 1937. The farm, a student-generated idea, was started to subsidize some of the cost of feeding the students and staff.

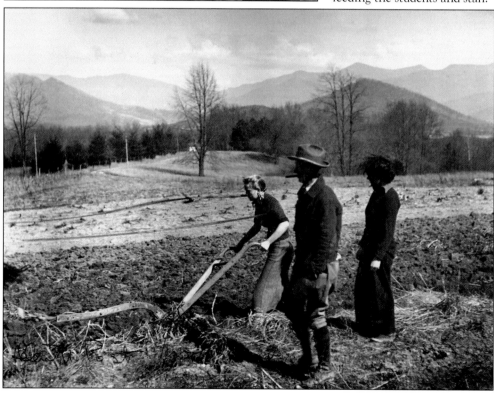

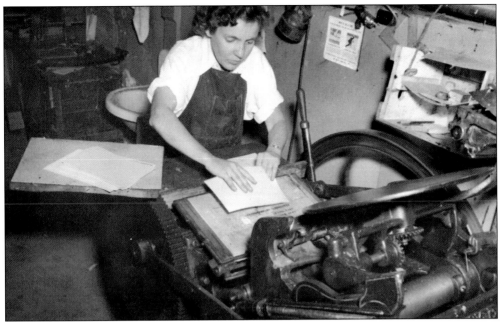

The printing press was located in the basement of Lee Hall and was run by students. Programs for theater performances, the college's academic year and summer-session bulletins, and other school forms were printed onsite. Above, Betty Brett works the printing press in the college's print shop. Below, Brett (left) and Emil Willimetz fold programs for the college's 1940 Visitor Week. Willimetz, who studied at the college from 1937 through 1940, set up the printing press with another student, David Way, and established Grafix Press. At the college, any student was allowed to set up and name their own press.

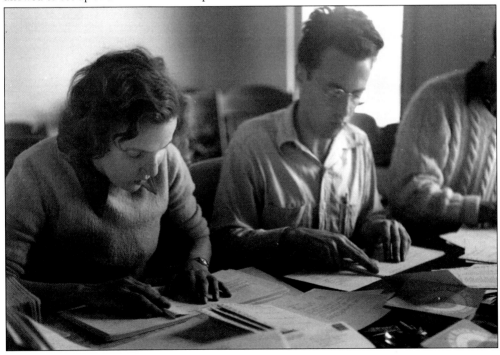

In April 1936, Louis Adamic, a Yugoslavian writer who had taken an interest in the college and spent several months visiting earlier in the year, published a long article in *Harper's Magazine* about Black Mountain College. Though the content of the article—specifically sections that credited Rice as the sole genius behind the school—was controversial within the college community, it is often credited with "saving" the school by providing much-needed publicity and, in turn, a bump in enrollment. Even years later, new students cited the article as the reason they came. Here, students Betty Kelley and Leonard Billing shoot a publicity photograph for the college captioned "Hand in hand through the fields [Craggy Mtns., NC]." Billing, one of the many students who first heard about the school through Adamic's article, was a student at the school from 1938 until he was drafted in 1941; he later returned as a woodworking faculty in the 1950s.

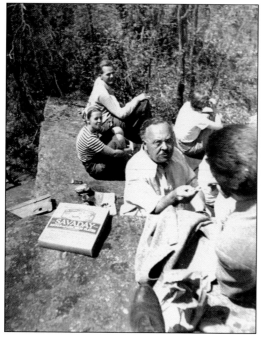

In May 1937, Aldous Huxley, author of many novels—most notably *Brave New World*—visited the campus. To celebrate the occasion, several faculty and students took Huxley on a picnic at Chimney Rock. Pictured are Anne "Nan" Howard Chapin (in striped shirt), who was one of the original students to attend the college in 1933; music faculty member John Evarts (behind Nan); John Andrew Rice (wearing glasses); Ted Dreier's wife, Bobbie (in white blouse); and Aldous Huxley (foreground, with back to camera).

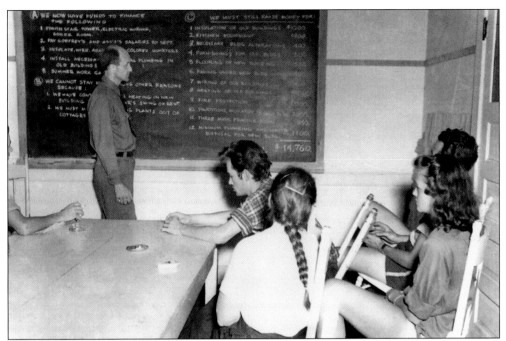

After many years at the Blue Ridge campus, with their lease on the property running out and the school's future and ability to grow on that campus uncertain, Black Mountain College purchased a summer-resort property across the valley at Lake Eden. In the above photograph, Theodore Dreier, one of the founders of Black Mountain College, holds a fundraising meeting for the building program in the spring of 1941 in preparation for the college's move to the new Lake Eden campus. Pictured from left to right are Ted Dreier (standing at chalkboard) and students Tommy Brooks (in plaid shirt), Eva Zhitlowsky (with braided hair), Connie Spencer (in shorts), and Francisco "Paco" Leon (behind Spencer). Below, Prof. John Evarts (left) looks over plans for Lake Eden with architecture professor Lawrence Kocher in the lobby of Robert E. Lee Hall.

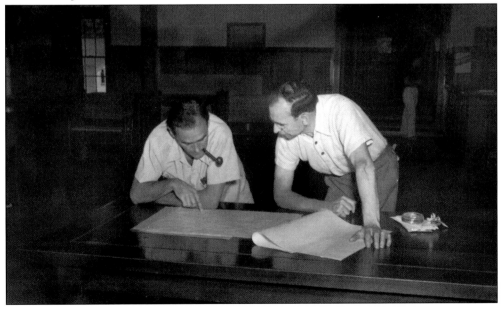

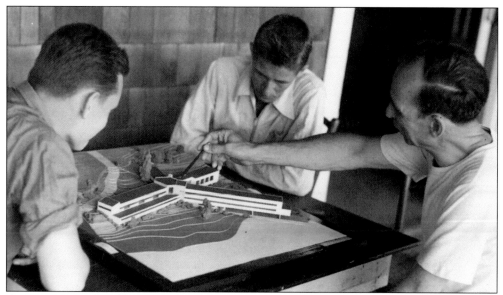

A. Lawrence Kocher (far right), the architect for one the most enduring structures constructed by Black Mountain College, shows his design for the Studies Building in 1940. The building was erected by students and faculty at the college between 1940 and 1941. The model seen in the photograph shows a building with four wings for student studies as well as space for a dormitory, library, and administration. The only portion of the model built was the long wing extending toward the lake.

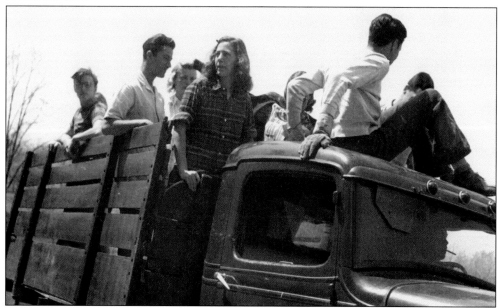

Besides the construction of the Studies Building, the existing facilities at the Lake Eden property had to be winterized and upgraded to fit the college's needs. With a great deal of work on the part of the faculty and students, the property was made habitable by the early summer of 1941, barely. That summer, the move was completed, and students shuttled pianos, looms, furniture, and the entire heating system (which they had installed years before) from Blue Ridge Assembly in trucks to Lake Eden.

Three

BUILDING A CAMPUS

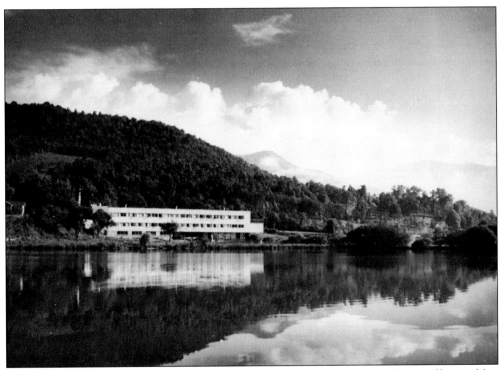

By the time the campus had relocated, John Andrew Rice had resigned—an affair and his sometimes abrasive personality having strained his relationship with much of the campus. The 1940s saw Josef Albers and Ted Dreier step up as leaders of the school. The Lake Eden property had originally been developed in the 1920s by E.W. Grove as a summer retreat for residents of his nearby planned community, Grovemont. Grove also constructed numerous buildings in nearby Asheville, most notably the Grove Park Inn. Grove's estate sold the 674-acre property to Black Mountain College in June 1937. The college operated the property as an inn and summer residence for the faculty until the college moved there full time in 1941. The Studies Building, pictured here across Lake Eden, still stands as an enduring reminder of the college that once operated on the property.

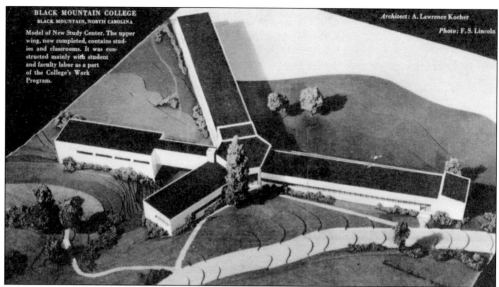

Walter Gropius and Marcel Breuer were commissioned to design several complex and modern buildings for the school's new property in 1939, but when fundraising began for the project, it was determined that in order to raise the amount needed ($500,000), the school would need to follow a more traditional academic model to appeal to the typical large donors. So the first plan was scrapped, and A. Lawrence "Larry" Kocher designed a simpler building that could be constructed with primarily student and faculty labor. Though the building was meant to consist of four wings, only the wing at far right in the picture was constructed.

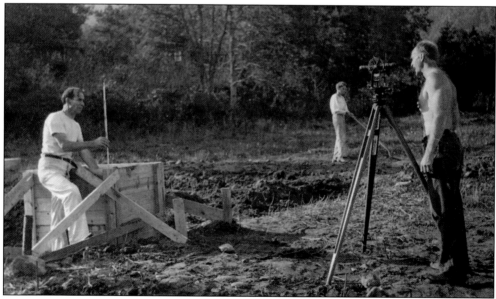

"We drove the piles, poured all the foundations, started putting up the wooden framing real fast to show as much as possible, took the pictures up north to the White House to show people we thought might help us, brought back the money, bought more materials and continued the cycles," Ted Dreier reported of funding the construction of the Studies Building. In the photograph, Lawrence Kocher (far left) and Dreier (far right) survey for the new building. They also used the project as a laboratory for their classroom teachings.

The piles for the building were all dug using the pile driver pictured. Farmer and campus handyman Bascombe Allen is pictured far left. Allen, a local man who had served the school at Blue Ridge, was hired as the head carpenter for the building. Known as "Bas," he often took students hiking and camping in the surrounding mountains and taught them about the trails and wildlife. Another local man, builder Charles Godfrey, became the contractor for the project.

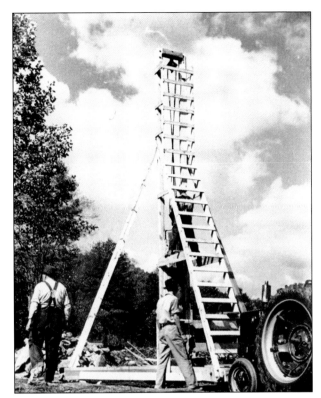

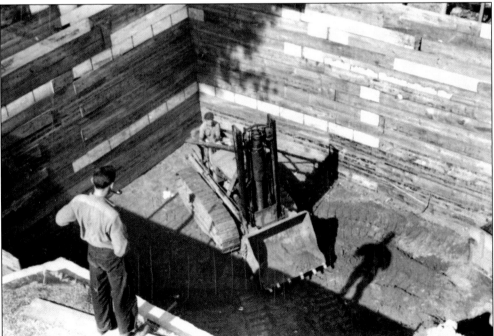

Prof. Robert Babcock stands over the foundation of the Studies Building watching student John Virgil "Danny" Deaver operate a tractor. Babcock taught political science at the school from 1940 to 1942.

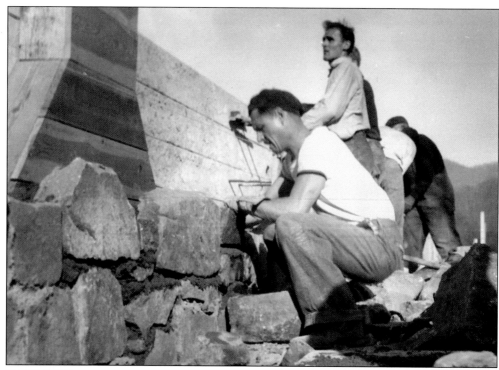

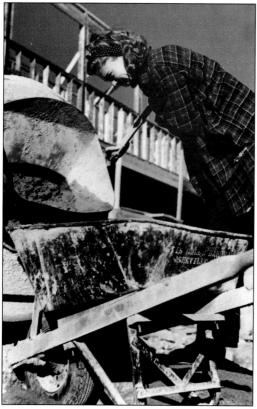

Construction on the Studies Building was begun in September 1940 with a budget of $5,000. Throughout the winter, benefit concerts and other events were held to drive donations for the continuation of the project. Faculty took a 60 percent pay cut in order to funnel more money toward completing the building. Above, professor Kenneth Kurtz cements part of the rock work along the foundation of the Studies Building. At left, student Jane Robinson uses a wheelbarrow to move wet cement.

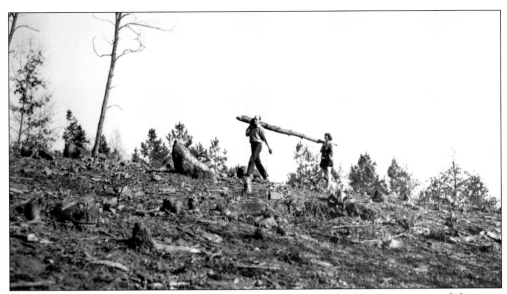

Using faculty and student labor was primarily a cost-saving method—it was estimated that over $25,000 was saved. But the project also received national publicity, which in turn drove donations to the program and students to the school. Construction became part of the unofficial curriculum at Black Mountain. Classes at the Blue Ridge campus were suspended in the afternoon and rescheduled in the evening so that students and faculty could go over to Lake Eden and work during daylight hours. Above, Ted Dreier and an unidentified student carry a log cleared from the property to be used for the building program. Below, Prof. Robert Babcock balances on the wooden frame of the Studies Building during construction.

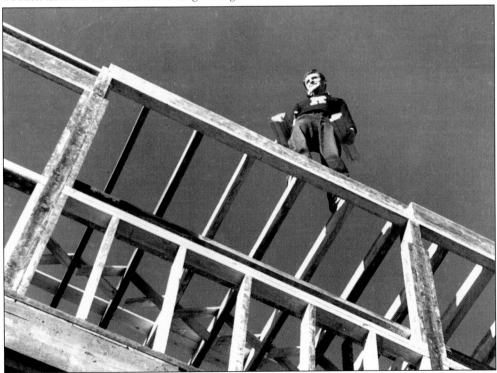

51

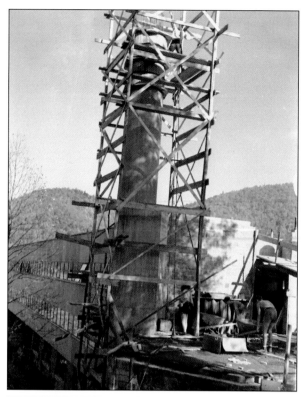

The lower floor of the Studies Building would house classrooms, a weaving studio, and other various storage areas, while the upper floor would be constructed as a space for student studies and faculty apartments. At left, the tower at the upper entrance to the Studies Building nears completion. Below, staff member Bas Allen (in hat) and students attempt to use a tree as a lever to unstick a tractor wheel from the mud behind the newly completed Studies Building.

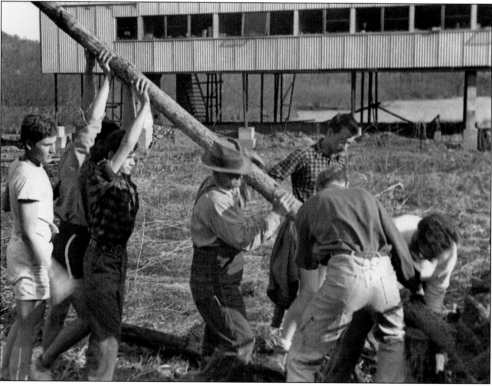

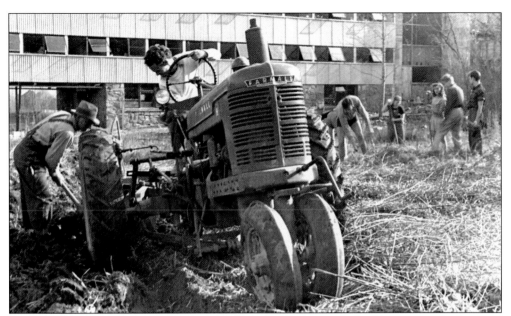

After the building was complete, drainage ditches were dug as the building sat on the banks of Lake Eden. In the photograph, staff member Bas Allen leans down to help free the stuck tractor while student Danny Deaver sits behind the wheel.

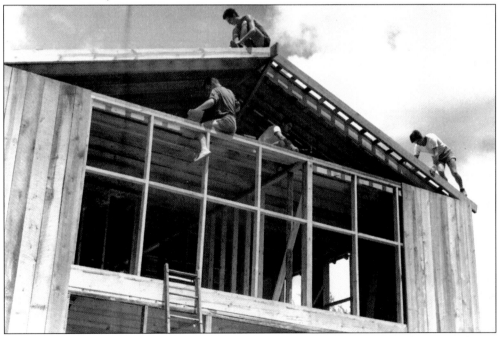

The Studies Building was not the only project being constructed on campus. In the spring of 1941, work began on a Service Building—also designed by Lawrence Kocher—for the kitchen and for African American staff to live in. Student Robert Bliss, who would later become an architect himself, was put in charge of construction. The building was completed quickly but was destroyed by fire in 1943. Pictured from left to right are students Jim Secord, Fernando Leon (at the roof peak), Jerry Wolpert (below Leon), and Robert Bliss.

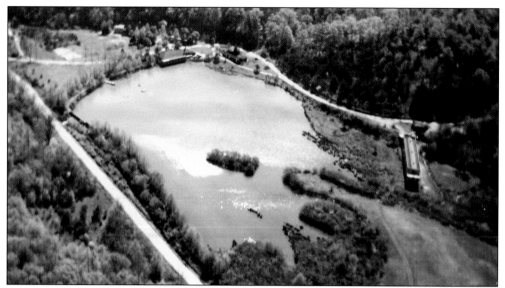

Construction and renovation continued for years, but the college became fully operational at the Lake Eden property by the summer of 1941. In this aerial shot of Lake Eden taken by Stuart Atkinson in a "cub" plane flown by Neil Albright, the Studies Building hugs the right side of the lake, the dining hall perches over the water on the left side, and Lake Eden Road forms a bottom border. The fields behind the Studies Building were in cultivation at the time but now have been flooded to form another lake.

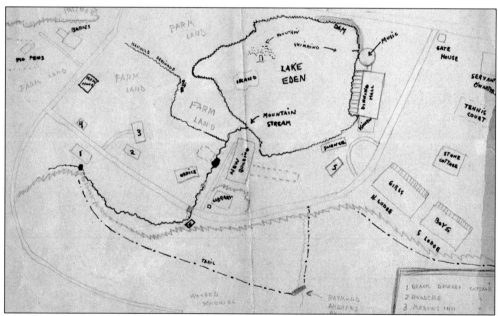

This hand-drawn map shows the location of many campus buildings. The Studies Building is labeled "New Building" on the map, with a second, never-built wing shown by a dotted line. Faculty homes, along with other common structures, are labeled with numbers off the road behind the Studies Building—1) Black Dwarf Cottage, 2) Roadside Cottage, 3) Meadows Inn Cottage, 4) New Cottage, 5) Brown Cottage, and 6) Tool Shed. The old Grove buildings are mainly grouped on the south side of the lake, including the dining hall, lodges, and gatehouse.

Student Kenneth Noland, who was from nearby Asheville, came to study at Black Mountain on the GI Bill from 1946 to 1948. He described the entryway to the school as "bright white boards, angled so that one entering was 'streamed' through." Noland would go on to become a world-renowned painter. Here, photographer Felix Krowinski's brother-in-law Herb stands at the entrance to the college off Lake Eden Road.

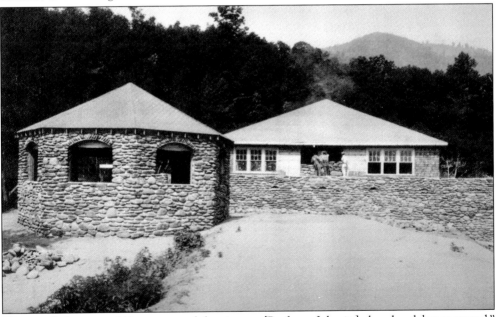

"Our small classes would hover around the piano as [Professor Jalowitz] played and demonstrated," remembered student Patsy Lynch Wood of being in the octagonal rock house known as "the Roundhouse" at Lake Eden. Pictured here are the Roundhouse (in the foreground) and the dining hall as they looked during construction in the 1920s. The Roundhouse was used as a music practice and performance space. (Courtesy of Swannanoa Valley Museum.)

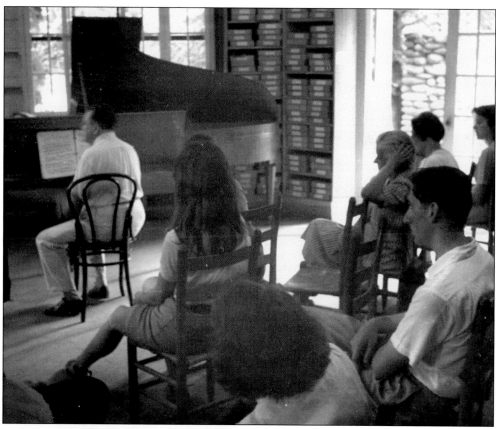

The Roundhouse was built by E.W. Grove and remodeled by Black Mountain College to include a heating system and wall shelves for music. Pictured above is the interior of the Roundhouse during a music class taught by Erwin Bodky. Bodky was a harpsichordist and pianist who had participated in the summer institutes in 1945 and 1947. He came back to teach full time in 1948 and to revamp the music program at the college, which had more or less become dormant since the death of Heinrich Jalowetz. At left, a student peruses the college's recording library.

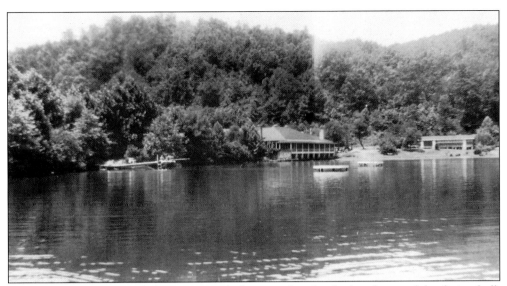

People were called to meals by a gong made from a railroad rail, placed west of the dining hall. "Wherever you happened to be, when the gong sounded at 15 minutes before mealtime, you had better be on your way. There are numerous accounts of late comers getting no meal!" recalled Mervin Lane in his book about the college, *Sprouted Seeds*. Pictured in this early photograph of Lake Eden (taken when it operated as a girls' summer resort in the 1920s) is the dining hall's screened-in porch overhanging the lake. The bathhouse is at far right. (Courtesy of Kay Green Cole Collection, Swannanoa Valley Museum.)

"The Dining Hall was such a comfortable place: I remember exhibits of Albers, especially his stained glass windows out of broken bottles and old screening . . . a special memory of breakfasts, with Mallory serving out huge piles of pancakes . . . evening performances, tables pushed to the walls, chairs placed for an audience—string quartets, plays, dance performances, lectures . . . Merce Cunningham, Bucky Fuller—all part of our food," remembered student Elizabeth Schmitt Jennerjahn of the Lake Eden dining hall. In the photograph, Charlotte Schlesinger (looking out the window, wearing glasses), Johanna Jalowetz (beside Charlotte in black shirt), and Elizabeth Schmitt Jennerjahn (in blouse beside Johanna) share a meal on the porch of the dining hall.

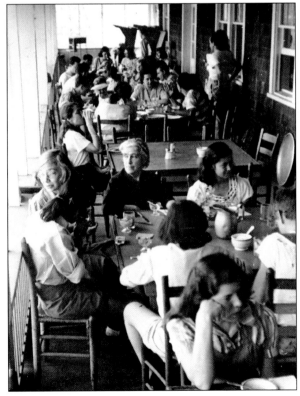

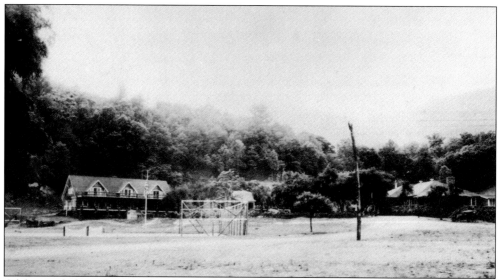

Of the two lodges where students lived at Lake Eden, *Sprouted Seeds* editor Mervin Lane recalled, "The center room in each [lodge] was open all the way to the roof beams, giving a more impressive feeling. South Lodge had a ping-pong table set up in the lobby. The small building was referred to as the Bachelor's quarters." The tennis courts, Stone Cottage, and South Lodge can be seen to the left of the dining hall in the above photograph. The North Lodge, pictured below, was closest to the dining hall and was the women's student dorm. The South Lodge housed the male students.

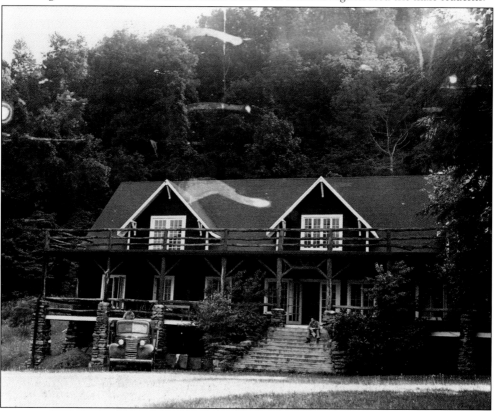

On October 8, 1941, near the Lake Eden dam, Ted Dreier's 9-year-old son Mark was killed in an automobile accident. The January 1943 *Black Mountain Bulletin* reported, "Before he left for a CPS Camp in West Compton, New Hampshire, Alex Reed finished the stone 'quiet house' he designed and built as a memorial to Mark Dreier. The house was built almost single-handed; Reed cut the wood, laid the stone, and wove the curtains at its windows. He felt that there was much value in doing constructive work during a time of destruction. He means the building to be used as a quiet place for quiet thinking, a place to get away, if only for an hour, from the pressure and business of the College." The memorial is an example of the closeness of the faculty and students and the sense of community shared on campus.

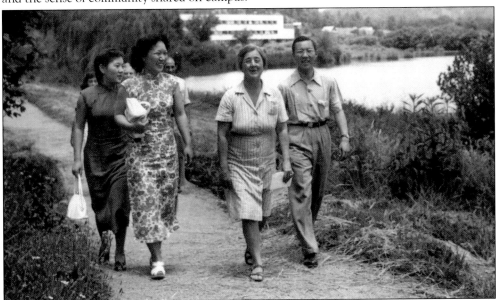

Beyond the Quiet House, a walking path ran around the lake to the library and the top of the Studies Building, connecting the two somewhat distinct parts of the campus. On one side of the lake stood the student dorms and dining hall and on the other, the Studies Building, classrooms, and the farm. Here, Alice Rondthaler escorts potential students visiting from China down the well-traveled path to the dining hall.

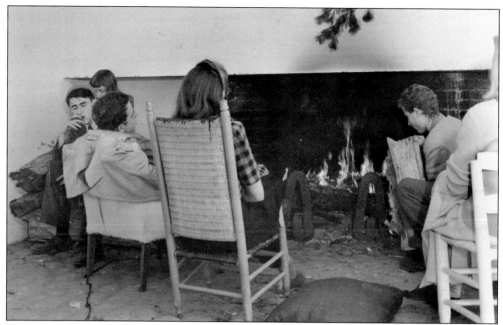

The lobby of Robert E. Lee Hall and its grand fireplace was a natural gathering place for students and faculty. Josef Albers wanted something similar to be built into the Studies Building—a "conversation" room. A fireplace room was built at the foot of the steel steps on the ground floor of the Studies Building. The photograph captures a rare moment when students gathered around the fireplace in that facility as the room was never comfortably furnished and was not often used. From left to right are Lucian Marquis, Faith Murray, Will Hamlin (possibly), Dodie Harrison, Otis Levy, and Mimi French.

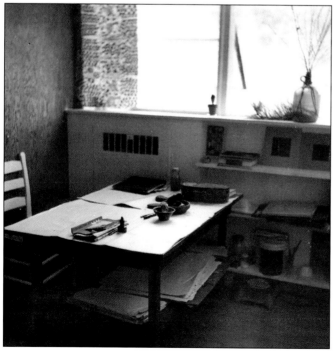

The tiny rooms built into the second floor of the Studies Building were constructed as student studies. The interior of one student's study can be seen in this photograph taken by Trude Guermonprez. Trude, born Gertrud Jalowetz, was a daughter of Heinrich and Johanna Jalowetz, both teachers at the college. She was a textile artist and, in 1947, began teaching at the college at the Alberses' invitation.

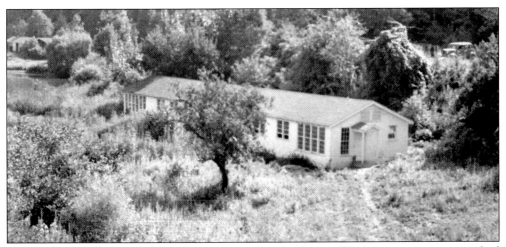

In the fall of 1945, though the college was not accredited, some Black Mountain programs had been cleared by the government for students to study under the GI Bill. An influx of students arrived (nearing 100), and more dorm and workspace was desperately needed. The college was able to acquire several deconstructed barracks from the Federal Housing Authority (FHA), which were put into use around the campus. Photographed from the Studies Building, this FHA building served as the library and was also used for classroom, exhibition, and study space. It was located just south of the Studies Building, along the lake. Below, when the library was moved downhill to the FHA building on the banks on Lake Eden, students formed a bucket brigade to transport the books from one location to the next. Molly Gregory is pictured at the back of the line of students.

The snowy road pictured above led up to many of the faculty houses that were built by the college—several of which are still in use as residences and offices by the current property owners. On the left in the photograph is the top of the Studies Building; on the right is the college's original library, also known as the "Community House" or "Lakeside," which contained quite a bit of John Andrew Rice's book collection that he left with the college upon his departure. Below, Mary "Molly" Gregory stands at center in the college's original library inside the Community House. The girl sitting on the right is possibly student Mimi French. The space was also used for social gatherings, exhibitions, and music practice. It was demolished in the early 1950s.

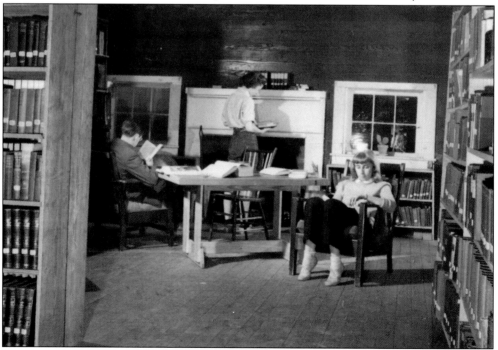

"Rarely has either an architect or a student had the opportunity to combine theory and practice of architecture so closely," said Paul Beilder of his experience designing and constructing the Beilder Music Cubicle in 1945. Beilder was an architect who came to teach at the college. The small music-practice room was located south of the Service Building, nestled in a pine grove and constructed to fit its surroundings. It has since been demolished.

The original science building, pictured here, which also contained the school's dark room, had been constructed by Grove as a bathhouse and sat on the banks of Lake Eden. It burned in 1948, so faculty member Paul Williams worked with students Dan Rice and Stan Vanderbeek to design a new facility in 1949. It took four years to complete the building because of problems with bending two-by-fours that caused the windows to shatter. The science teacher at the time, Natasha Goldowski, refused to use the building because of concerns it would collapse.

"I spied against the wall a foot operated printing press antique even in 1946. We spent months cleaning up the shop, oiling the press . . . installing a motor from a defunct faculty Kelvinator . . . We went to town producing concert programs, student and faculty creative writing—you name it," remembered student Jimmy Tite of resurrecting the printing press, which had been in storage during the war years. This oblong, wood-frame building was constructed in 1941 to house the woodworking shop and the print shop. It still stands and is now used for storage.

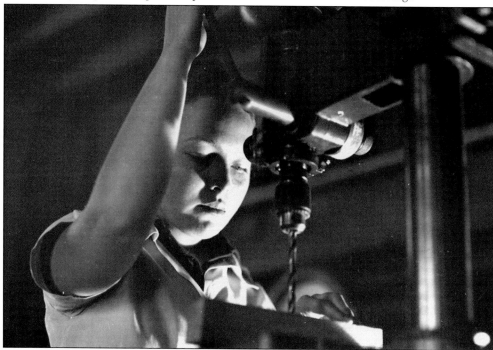

"When I arrived, I neglected to secure any furniture for my study. People said why not go up to the woodshop and make something. At home we owned no tools . . . I decided to make . . . a writing surface. It was a miserable desk. But it was all mine," said student Harry Weitzer of his experience at the college woodworking shop. Weitzer would go on to become a wooden-furniture maker and found the Oregon Craftsmen. In this portrait by Claude Stoller, student Eva Zhitlowsky works in the shop.

Several faculty homes were constructed on the road north of the Studies Building. This photograph shows the faculty residence known as Roadside Cottage. From 1941 until 1949, the Dreier family and the Alberses lived in the cottage together. Though there were separate apartments at either end of the house, the two families shared a common living space in the center of the home. The cottage burned in 1953.

The Jalowetz house was designed by Lawrence Kocher in the spring of 1941 to be constructed by unskilled labor and serve as the residence for Heinrich and Johanna Jalowetz, instructors at the college who had fled Hitler's regime in Germany. The living room of the home, pictured here, was designed and built to also serve as a music classroom. Heinrich died in 1946, and Johanna lived in the house until 1953 when she left the school. After her departure, rector Charles Olson and his family moved into the house.

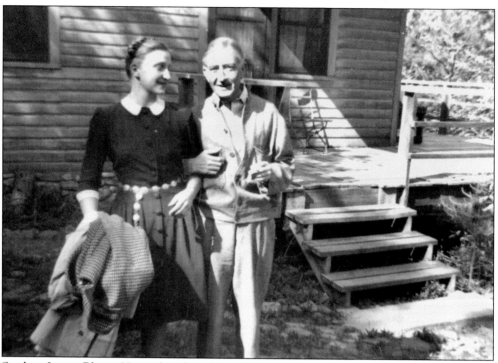

Student Lorna Blaine Howard and Prof. Josef Albers stand together in front of the home of German-born mathematics professor Max Dehn around 1946.

Student Tasker Howard sits on a fence in front of one of the government housing apartments utilized by the college in 1948. The college gave all the FHA buildings that were reconstructed on the property unique names to identify them. Howard and his wife, Lorna Blaine Howard, were one of the married couples to live in the building shown—referred to by the college as "Last Chance." Last Chance and its counterpart, "Next-to-Last-Chance," each had three apartments with a living room, bath, bedroom, and kitchenette and housed faculty and married students. The buildings came from an airbase in Maxton, North Carolina.

Even during construction and renovation at the Lake Eden campus, the students and faculty continued to farm. When the Lake Eden property was purchased by the college in 1937, the farm program was expanded to include the additional land. The campus farmhouse was built down the hill from the barn by Mary "Molly" Gregory and students in the summer of 1946 to provide housing for two families who were moving to the college to take care of the farm. Gregory headed up the farm until 1946 when the school hired two Quaker couples—Clifford Moles and his wife, Shirley, and Raymond and Dorothy Trayer—to take care of it.

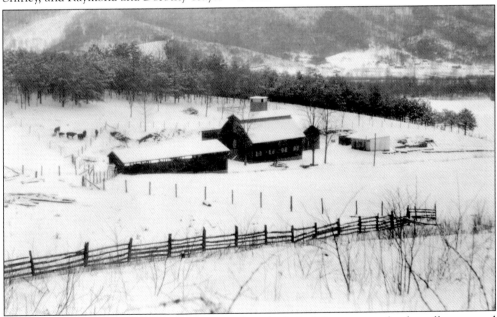

A small barn was the first building constructed on the Lake Eden property by the college around 1938. Once they relocated permanently to the new campus, architect Lawrence Kocher designed the large barn that still stands today. It was constructed by the spring of 1942. In 1943, students helped construct two glazed-tile silos. Shirley Moles took this photograph of the barn and surrounding buildings during the winter.

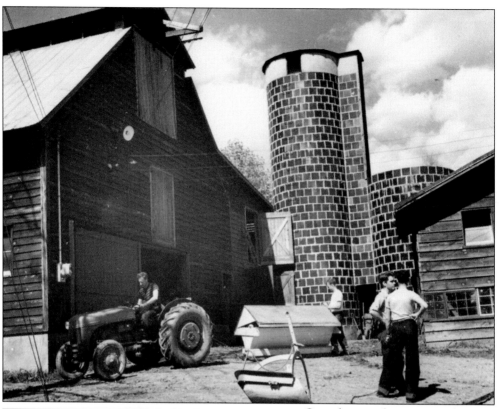

Over the next few years, students and faculty would construct a shed for beef cattle, a milking parlor, a milk house, a brooder house, a laying house, a calf barn, an equipment shed, a hog house, and a tobacco barn. In the above photograph, taken by student Jerrold Levy, the large barn designed by Kocher is on the left, the two silos sit at center, and the 1938 small barn is on the right. At left, faculty member John Evarts lifts hay into the barn's hayloft.

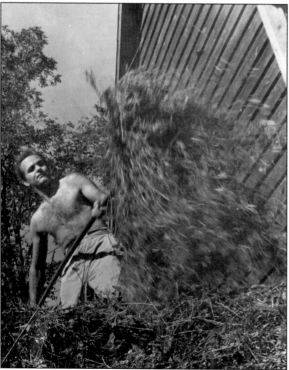

Farmers Ray Trayer and Cliff Moles taught the students new organic farming techniques, which greatly increased the quality of the soil and the farm's efficiency. Student Bernard Karp (with feed bag) works with farmer Raymond Trayer in the shed behind the main barn. Part of the milk house can be seen in the background. Though Moles left the school in 1948 over conflicts with Trayer, Trayer stayed on and became an instructor, also serving on the board of fellows.

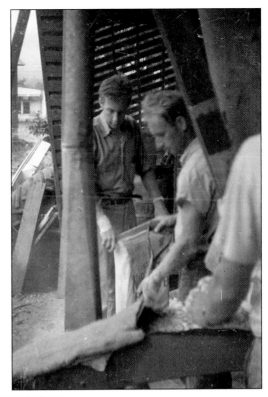

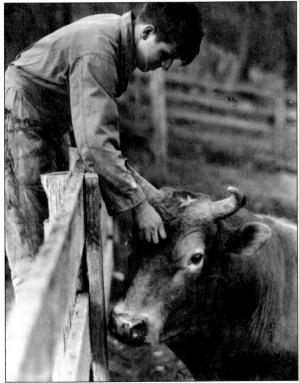

Crop rotation, planting, harvesting, milking cows, composting, caring for livestock, and so much more were part of the farm work at Black Mountain College. They grew silage, clover, lettuce, strawberries, oats, and barley, which required plowing, pulling weeds, moving rocks, and clearing fields. All of this was, as Molly Gregory remembered it, "done with student help, hard work, and excitement." Student Howard Rondthaler works with one of the college's cows around 1947 in this Felix Krowinski photograph. Krowinski was a student at Black Mountain in the late 1940s.

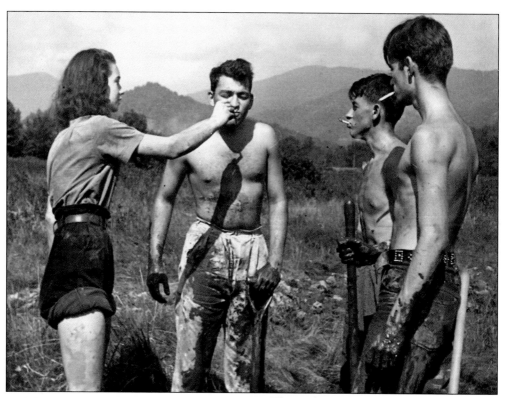

The work program continued to be an important part of the campus throughout its life. Students were needed to keep the campus operational and financially solvent, but the work program also challenged students to learn new skills and work together to solve problems. In the above photograph, from left to right, students Peggy Clamp, Edwin Kaye, Lucian Marquis, and Tommy Brooks take a break from digging ditches. At left, student Barbara Sieck mixes cement in her worn-out and very patched work pants.

"The work program had greater educational value than recognized at the time and certainly instilled a responsibility for community service that remains with us . . . it was surely invented by necessity to share chores for an economical and harmonious existence. The value of physical work, of the whole mind-body routine (as opposed to required PE credits) must have been embraced later. My introduction to the work was in gathering apples, converting them to cider through a hand-cranked press . . . The next experience was more strenuous in emptying a railroad car of coal at the Black Mountain siding and transporting it . . . in the old Chevy truck," remembered student Robert Bliss. At right, Ronald Jackson, Vera Baker Williams, Mickey Miller, and Gregory Masurovsky shovel coal from a train car into the college truck. Below, student Jerrold Levy jumps into a coal pile about 1950.

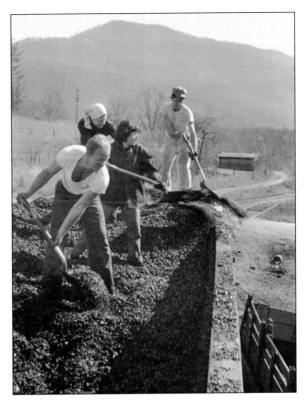

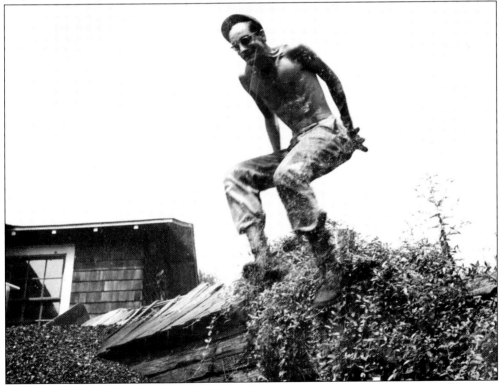

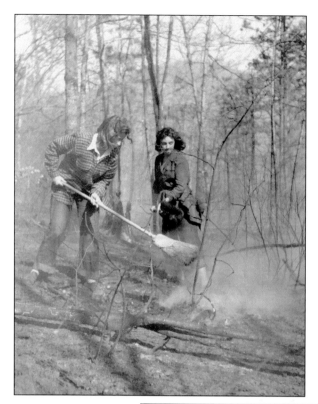

Shown here in this c. 1949 Tom Leonard photograph, Ruth O'Neill (left) and Suzanne Noble (right) were two of the students who dropped their books to help put out a forest fire that threatened the entire college property. Robert Babcock, professor of government and head of the college's fire department, said that only the excellent and immediate response of the entire campus community to the alarm saved the property from a disastrous fire.

After several fires that burned campus buildings to the ground and a forest fire that threatened the entire campus, Asheville's fire chief visited the college to teach students and faculty to use firefighting equipment. Molly Gregory stands at far left.

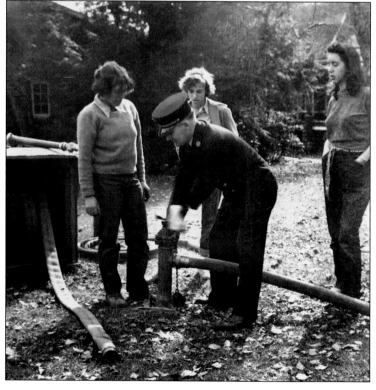

Four

LAKE EDEN

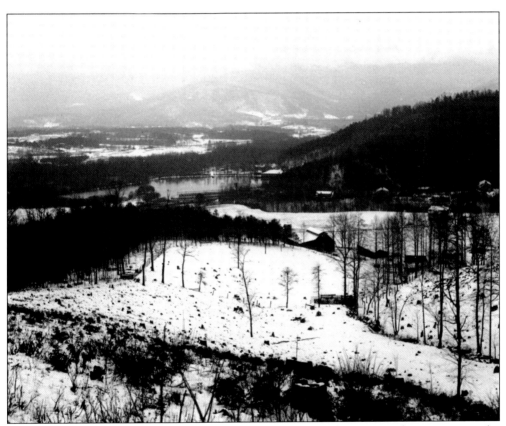

Though the Lake Eden campus was always a work in progress, classroom studies, extracurricular activities, and the other activities associated with life at Black Mountain College continued as usual. This photograph, taken by Trude Jalowetz Guermonprez in the winter of 1949 from the hill over looking the farm, shows the barn, the Studies Building, Lake Eden, and the surrounding property as it looked in the snow.

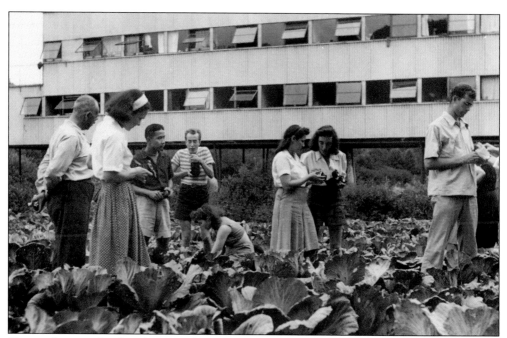

Here, a photography class shoots in the summer of 1944 in the collard patch between the Studies Building and the lake. Faculty member Josef Breitenbach stands at far left. Student Ruth O'Neill (center, dark shorts) works with another student. Student Charles Forberg stands far right with Josef Albers (only hands showing).

Pictured are, from left to right, (first row) Ruth O'Neill and instructor Robert Babcock; (second row) music faculty member John Evarts, language instructor Frances DeGraaff, unidentified student, William McLaughlin (plaid jacket), unidentified student, Eva Zhitlowsky (with head resting on hand), and unidentified student. Babcock taught at the college from 1940 to 1942.

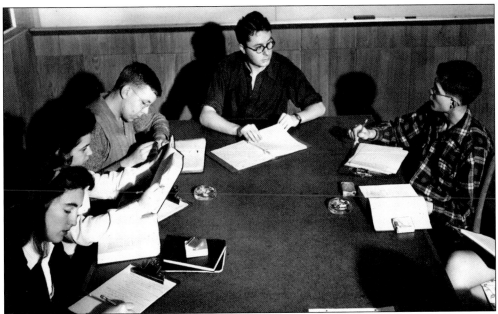

Eric Bentley's class meets in the Studies Building about 1943. Bentley, a young professor at only 25 years old, taught history and drama at the school from 1942 until 1944. Seated second from left in the photograph is student Ruth O'Neill. Bentley sits at center in a dark shirt. While at the college, Bentley read all the books on theater in the school's library, which resulted in *The Playwright as Thinker*, his famous study of modern drama.

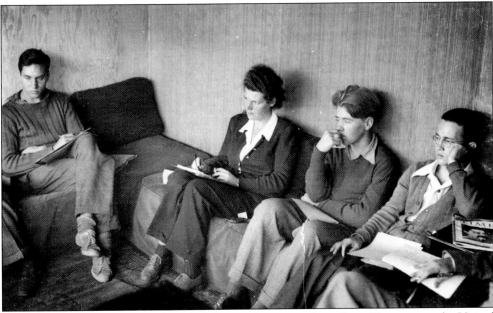

Frances de Graaff taught languages and Russian history at the college. She came to the United States in 1939 from Russia, where she had received her doctorate in literature and language. She arrived at the school in 1941 but resigned in 1944 with several other professors, including Eric Bentley, after infighting among the faculty caused a split in the school. De Graaff is pictured second from left.

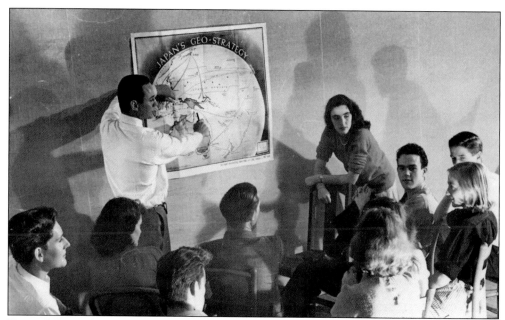

Kenneth Kurtz (standing) taught English and American literature at Black Mountain College from 1938 to 1944. Here, he speaks to his students about Japan at the beginning of World War II. The war had a dramatic impact on the college, and many European refugees came to teach or study. After the war, the GI Bill financed the education of many students and was critical in the survival of the school.

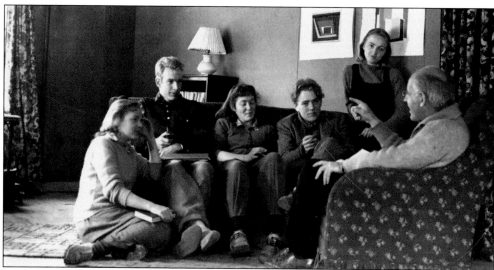

"Never before or since have I been in a community where there was so much excitement about ideas. I took classes, yes, Psychology of the Human World with Erwin Straus—three times . . . we never got past Descartes. Once I asked him about psychology in the 20th century. His disinterested response —'just read through any text book you want, it's all there.' But the thinking was mysterious and strenuous, serious, and totally new to me," remembered Straus's student Mary Brett (Daniels) of his courses. This photograph shows one of Straus's psychology courses around 1942; pictured from left to right are Mary Brett, Bob Marden, Barbara Payne, Erik Haugaard, Jackie Tankersley, and instructor Erwin Straus. Straus taught psychology and philosophy from 1938 until 1944.

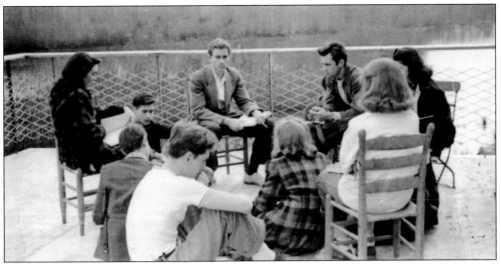

"If challenging a student to explore and analyze concepts as well as the evidence on which they are based and make[ing] such an exercise stimulating and enjoyable [are marks of a good teacher], then Jack French was my best teacher. He encouraged his students to think for themselves, often playing the 'devil's advocate.' He encouraged me to pursue independent study of perception and let me teach what I had learned to one of his classes," said student Gisela Kronenberg Herwitz. In this image, Jack French (with light hair, center) teaches a psychology class on the porch of the Studies Building.

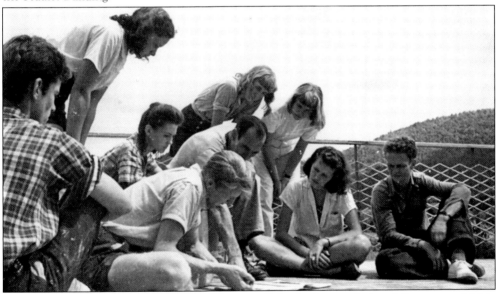

"Larry's teaching was largely 'hands on.' We generally built what we designed. Larry was a highly experienced and dedicated architect who nonetheless made us feel that he accepted us as colleagues," said student Claude Stoller of architecture professor Lawrence Kocher. Here, Kocher teaches on the porch of the Studies Building about 1942. Pictured from left to right are Tommy Brooks (far left), Renate Benfrey (standing, in profile), Dick Wykes (seated, wearing dark shorts), Betty Kelley (squatting in plaid shirt), Lawrence Kocher (in striped T-shirt), Mimi French (standing, dark shorts), Alexandra Weekes (standing with hands between knees), Connie Spencer (seated, cross-legged), and Virgil "Danny" Deaver (far right).

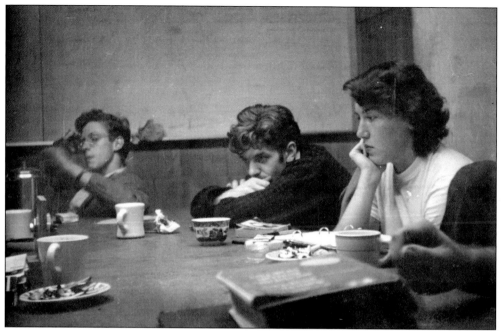

Here, William "Bill" Levi's class meets in the Studies Building. Pictured from left to right are Harry Weitzer, Jesse Dawes Green, and an unidentified student. Coffee and cigarettes were part of the casual campus atmosphere. Levi, who taught social science and philosophy, often smoked his pipe during his lectures.

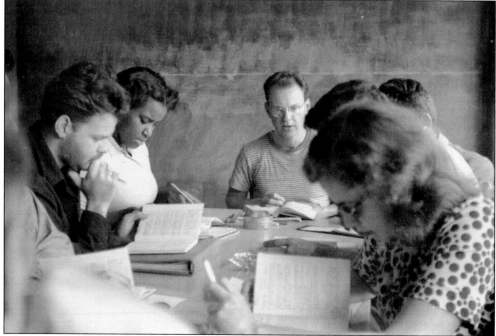

In this image, Frank Rice's class meets in the Studies Building. On the left side of the table are Knute Stiles and Delores Fullman. In the center is Frank Rice, the son of John Andrew Rice. He joined the faculty in the summer of 1947 and taught German language and literature.

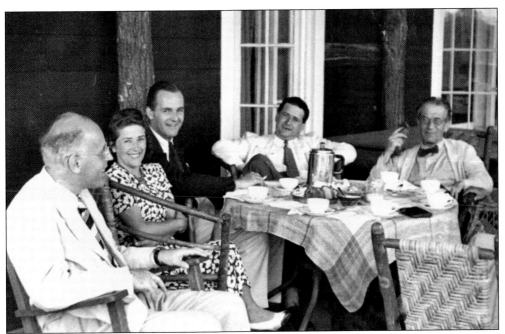

In this photograph taken by Lisa Jalowetz of a faculty lunch are, from left to right, Erwin Straus, an unidentified female, John Evarts, an unidentified male, and Heinrich Jalowetz. Heinrich, lovingly referred to as "Jalo" by students, taught music. He died of a heart attack in 1946 and was buried on the Lake Eden property.

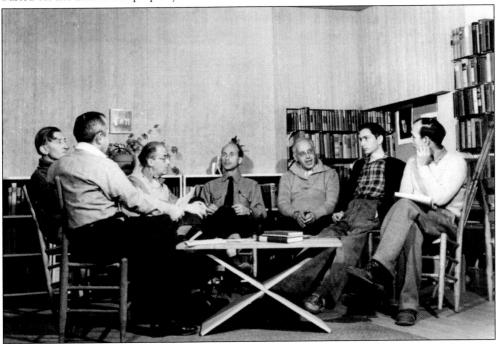

Seated around the table are, clockwise from left, Robert Wunsch, Josef Albers, Heinrich Jalowetz, Theodore Dreier, Erwin Straus, unidentified (possibly the student moderator), and Lawrence Kocher in a faculty meeting.

Faculty member David Corkran sits in the college's exhibition room. Corkran taught American history and literature from the spring of 1945 until he left the college in September 1950, moving his family into the village of Black Mountain, where they stayed until 1954. His son John Corkran remembered, "My father experienced both sides of the coin and he left the college in 1950, grateful for the students he had taught, many of whom remained life long friends, but frustrated and disappointed at the loss of vision he felt the college was experiencing."

In this photograph by Jerrold Levy, mathematics instructor Max Dehn teaches a course in his classroom. Max Dehn passed away in 1952 while an instructor at the college. He, like Heinrich Jalowetz, is buried on the Lake Eden property. Though he was a noted mathematician, he taught philosophy, math, Greek, and Italian while at the school.

Fritz Hansgrig, a German refugee, came to Black Mountain to teach physics and chemistry from an internment camp where he was kept briefly during the war on suspicion of being a Nazi sympathizer. He was paroled into the college's custody. Before his arrival, he had been key in experiments that allowed for the extraction of magnesium from seawater. He tried to set up a similar a process at the college to help with funding, though his efforts eventually amounted to nothing, partly because of a fire that destroyed his plans. He left the college in 1948, helping choose Natasha Goldowski as his replacement just before leaving. He died unexpectedly at the college in 1949 at the age of 58.

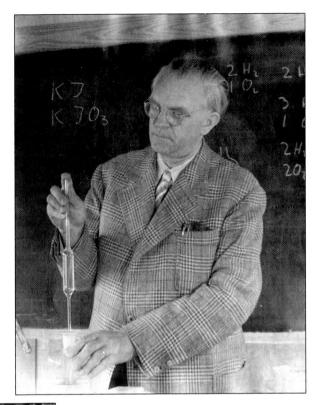

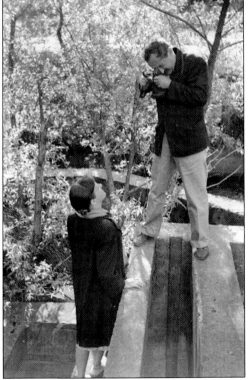

Ilya Bolotowsky is pictured photographing his wife, Meta, from a higher perspective. Bolotowsky was born in Russia and became a well-known painter and sculptor. He taught at Black Mountain and chaired the art department from 1946 to 1948 in place of Josef Albers, who was on sabbatical.

"Black Mountain's contribution was that you could live creatively simply by the way you looked at life and the way you lived it. I didn't learn technique at Black Mountain. I learned a point of view," said Molly Gregory of her time at the college. Pictured here, Gregory came to Black Mountain in 1941 to work as Josef Albers's apprentice teacher, and the following year, she became a woodworking instructor. With most of the college's men enlisting, Gregory took over the woodshop. Throughout her time there, Gregory at various points also directed the work program, ran the farm, and served on the board of fellows. She left Black Mountain in 1947 to become manager and designer at a woodworking shop in Vermont set up by a former student.

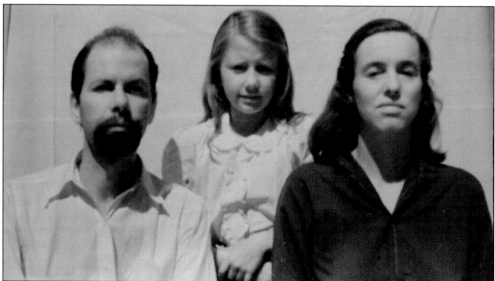

In this family portrait taken by student Felix Krowinski, Albert William "Bill" Levi and his wife, Mary Carolina "M.C." Richards, pose with their daughter Estelle. In 1945, Levi came to the college to teach philosophy and the social sciences. Richards was hired to teach writing and literature and was a potter and poet. The couple separated while at the college, and Levi left the school in 1950. Their daughter Estelle recently visited the Western Regional Archives and discovered this family portrait for the first time. When asked about the sad faces, she simply replied, "It was not a happy time for my family, but I still think of the college often. There were good times too."

The campus site was situated with a lake, streams and creeks, mountains, forests, nature, and sky all around it. Many classes took advantage of these views, especially art classes. In the photograph, an art class paints on the balcony of the Studies Building. A landscape that includes the Studies Building is taking shape on the center canvas. Nature and the Studies Building continued to be themes in student projects over many years.

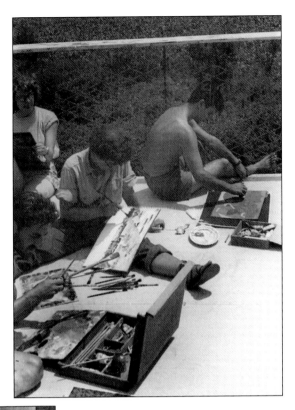

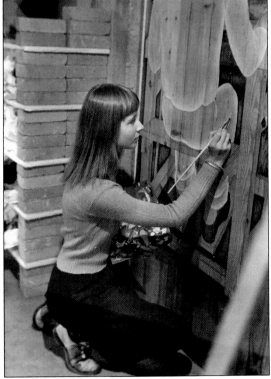

Faith Murray (Britton) kneels to paint the weaving room door in the summer of 1942. The painting, called *The Weaver*, was modeled after Don Page, the college's first graduate in weaving. Murray applied to the college in 1941 and studied painting under Josef Albers. She dedicated herself to learning techniques and opening her artistic eye and was quite successful in doing so, according to letters home from her professors.

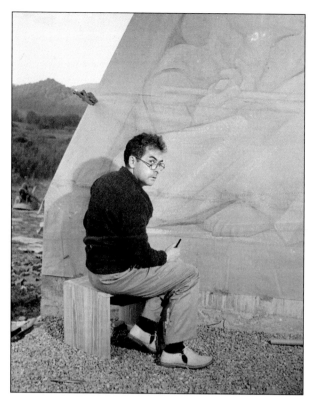

At left, artist and faculty member Jean Charlot outlines his fresco titled *Inspiration* on one of the cement pylons under the Studies Building in 1944 in a photograph taken by Joseph Breitenbach, who taught photography during the summer of that year. Below, painter and sculptor Jose Mariano de Creeft, who was born in Spain and taught at the college in the summer of 1944, sketches under the Studies Building in front of one of Jean Charlot's finished frescoes.

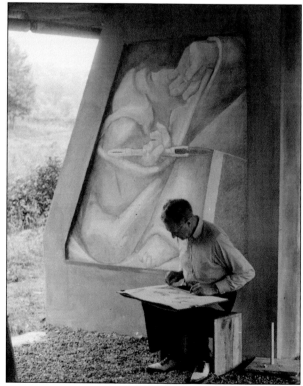

One lesson in Josef Albers's courses was *mattiere* (or "material") study. In this lesson, students would redefine what was typically thought of as an artistic material. Art was created with found objects such as leaves, corrugated cardboard, and scrap. Albers's goal was to show that not every combination of objects creates art; rather, art is created in how these objects are manipulated and arranged. At right, two students experiment with new and different materials (such as eggshells) in Albers's material study class. Below, in this Joseph Breitenbach photograph, Albers teaches a color studies course in the summer of 1944.

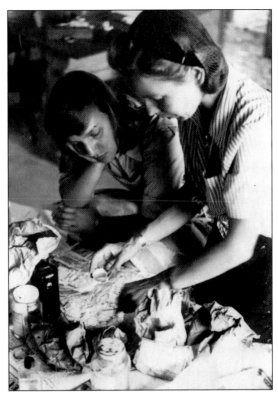

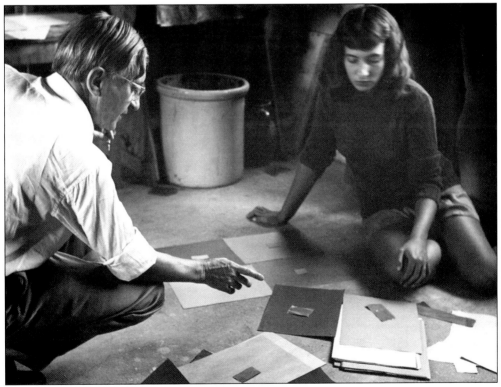

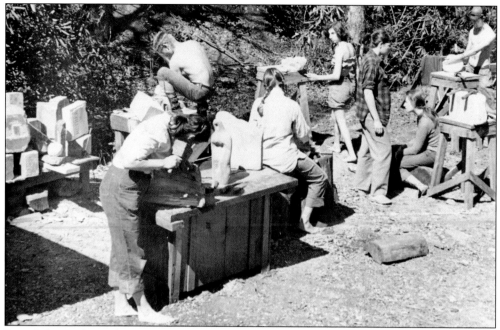

From left to right in this 1948 photograph of a college sculpture class, Dorothy Albers (far left), Stanley Hebel (back to camera), Randy Geissbuhler (braid), Sheila Oline (halter top and shorts), Marion Rothman (plaid shirt), Susha Dickson (sitting), and Gregory Mazurovsky (far right) work with wood and clay.

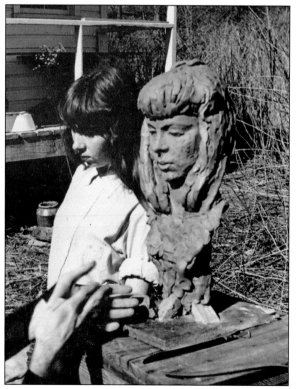

When students showed an unusual competence in a particular area, it was not uncommon to have them give a course in that field. Student Harry Holl was so gifted in sculpture that he conducted a sculpture class in the spring of 1948. Prof. Bill Levi said of Holl, "He has by no means reached his full artistic maturity but he is extremely gifted both in his conceptions and his craftsmanship . . . and I think it was one of the most successful classes taught that semester by students or regular faculty alike." Here, in the fall of 1948, Harry Holl sculpts a bust of Mirande "Randy" Geissbuhler, who would later become his wife.

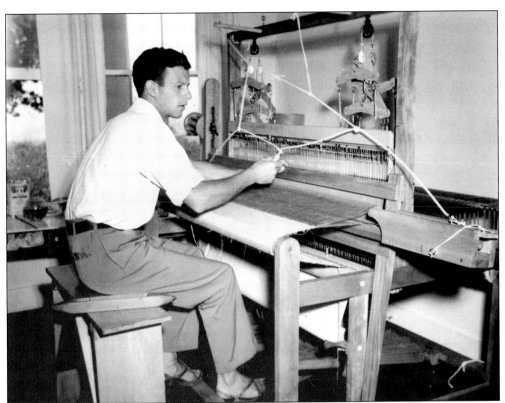

With Anni Albers in charge of the weaving program, the college attracted textiles artists. Above, Alexander "Bill" Reed weaves on a college loom in class. The Trude Guermonprez photograph to the right shows a textile exhibition at the college. Exhibitions of student and faculty work were common occurrences on campus. This textile exhibition may be the Harriet Englehardt Memorial Collection. Englehardt was a student killed in a jeep accident while serving overseas with the American Red Cross. Her family created a textile collection in memory of her and donated it to the college.

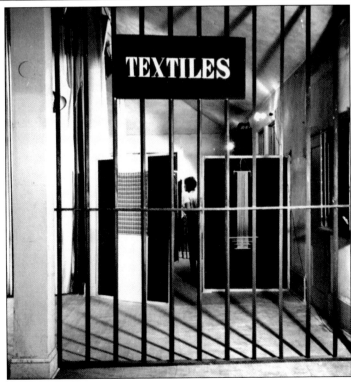

In the above photograph, students and faculty take part in a rehearsal of Moliere's *The Physician in Spite of Himself* in the dining hall. Actors waiting for their next scene are Leslie Paul (far left, black scarf) and Shirley Allen (second from left, white scarf). In the center of the image, watching the rehearsal are Frances Kuntz (fourth from left), Marilyn Bauer (leaning down to take notes), and Bob Wunsch (with legs crossed). The others are unidentified. Wunsch left the college in 1945 when he was arrested in Asheville for "crimes against nature" (i.e. homosexuality). Though quickly released from prison, Wunsch resigned from the college immediately and, under an agreement with the board of fellows, returned to the campus to retrieve his things in the dead of night. Below, student Jackie Tankersley helps Tommy Brooks dress for his role in *The Physician in Spite of Himself* in December 1941.

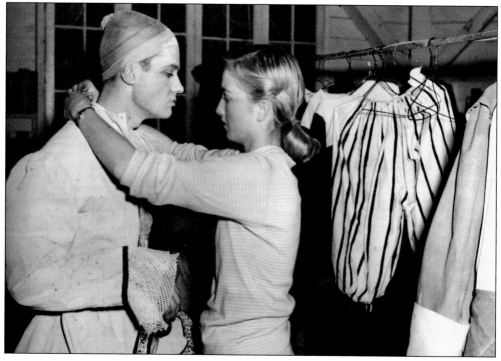

After Bob Wunsch left, drama at the college was, for several years, almost nonexistent. In 1947, Arthur Penn, who was 24 at the time, came to study at the school. He offered informal theater classes and began to direct plays; he would go on to direct major Hollywood films. At right, student Claude Stoller wires stage lights for a drama production. Below, students take part in an unidentified drama production.

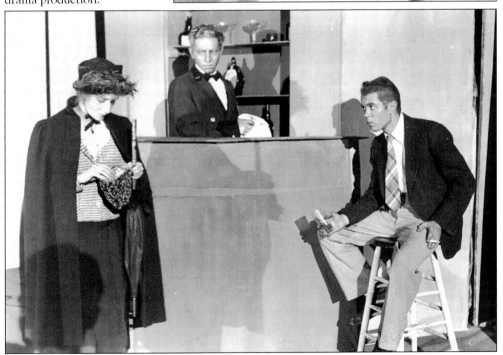

In the summer of 1944, Heinrich Jalowetz (in bow tie) plays the piano for his music class. Also pictured are Frederick Cohen (to the right of Jalowetz) and Erwin Straus (partially shown at far right).

Music faculty member Gertrude Straus (far left) performs with fellow faculty Gwendolyn Currier (cello), Heinrich Jalowetz (piano), and Gretel Lowinsky (violin). Straus was a key sponsor of the Black Mountain College Summer Music Institute in 1945, which featured, according to the school's bulletin, "music lectures, tutorials, open rehearsals, concerts, and courses on the rise and development of vocal and instrumental polyphony with special emphasis on the small ensembles of chamber music."

In 1944, the college began to hold special summer institutes in art and music, attracting a wide variety of well-known visiting instructors throughout the years. Pictured here is a faculty group in the summer of 1944. Josef Albers sits in front. Behind him are, from left to right, James Prestini, J.B. Neumann, Walter Gropius, Jose de Creeft, and Jean Charlot.

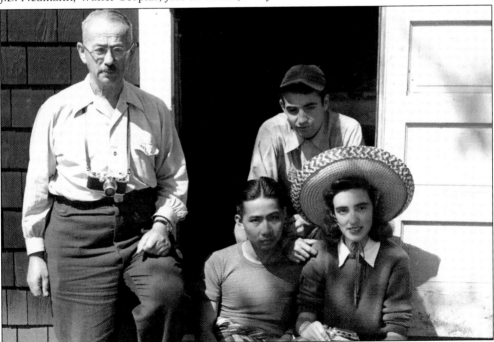

In this photograph by Barbara Moran, summer students take pictures of the Grove buildings at Lake Eden during a photography class with Joseph Breitenbach (left, with camera around his neck). The girl in the hat is Ruth O'Neill.

Students at the 1946 Summer Art Institute constructed this Trojan horse for a Greek party under the instruction of Jean Varda, who is pictured at far right climbing onto the horse in this Beaumont Newhall photograph.

Costume parties were a summer-session favorite. From simple to elaborate, students and faculty would go all out to create the perfect look to match the theme. Here, student Evelyn Bullock is photographed in her costume for a party at the 1949 Summer Institute.

In this photograph taken by Masato Nakagawa, a group of students goes swimming at a local swimming hole during the 1949 Summer Institute.

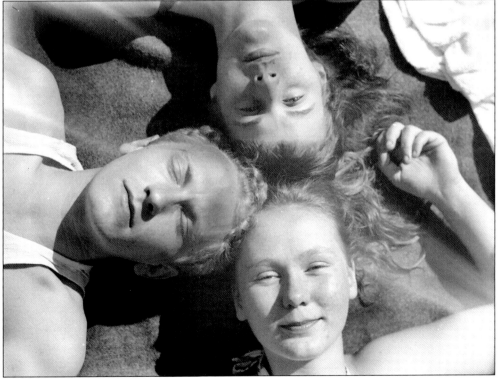

Clockwise from left, Gustave Falk, Dorothy Albers (Orr), and Kendall Durant (Ramsey) lie in the sun in this Felix Krowinski photograph taken around 1947.

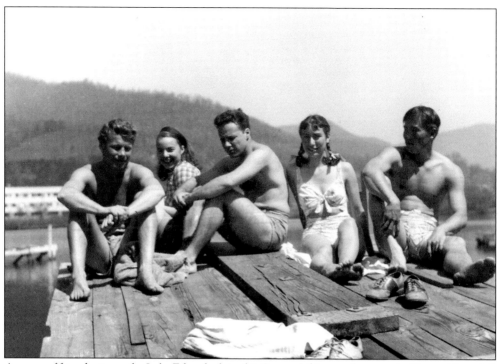

A group of friends sits on the Lake Eden dock in this Stuart Atkinson photograph. Pictured from left to right are Francis Foster, Nancy Dunn, Lenny Schwartz, Bernice Bernstein, and Ike Nakata.

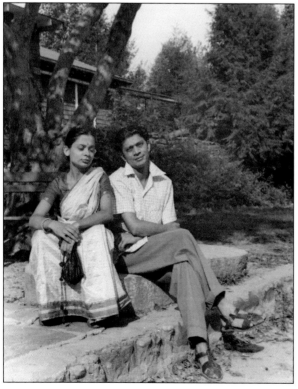

Faculty members Nataraj Vashi and his wife, Pra Veena, pictured here, taught philosophy and Hindu dance at the college during the 1949 Summer Institute.

Buckminster Fuller naps in the shade during the summer of 1949. Fuller taught at the college during the summer sessions of 1948 and 1949. It was there, with the help of other faculty and students, that he was able to construct his first freestanding geodesic dome that could sustain its own weight.

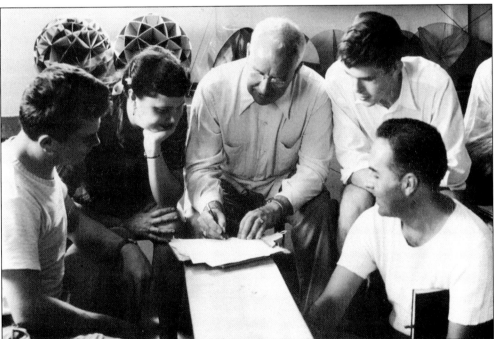

This is Buckminster Fuller's architecture classroom as it looked in the summer of 1949. Pictured from left to right are Kenneth Snelson, Jane "Jano" Walley, Buckminster Fuller, Charles Pearman, and John Walley.

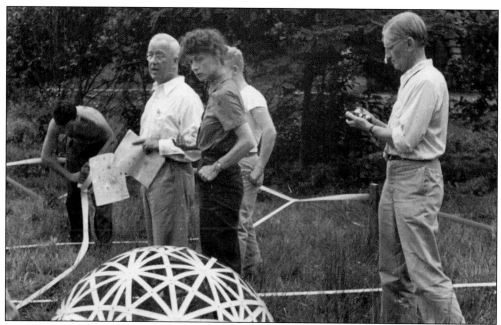

Buckminster Fuller, when he tried to erect his first geodesic dome at the college (using venetian blinds), referred to the effort as his "supine dome," as it never stood and was unable to support its own weight. He said that he got the "sort of feeling it wanted to go up, but it was limpid and settled down like a pneumatic bag that had little air in it." The above photograph, taken by photography instructor Beaumont Newhall, is of Buckminster Fuller, Elaine de Koonig, and Josef Albers on the lawn of the Studies Building, attempting—with the help of students—to erect Fuller's venetian blind dome. Fuller was invited to teach beginning in the summer of 1948. Below, the dome is laid out, and students insert bolts into the overlapping segments.

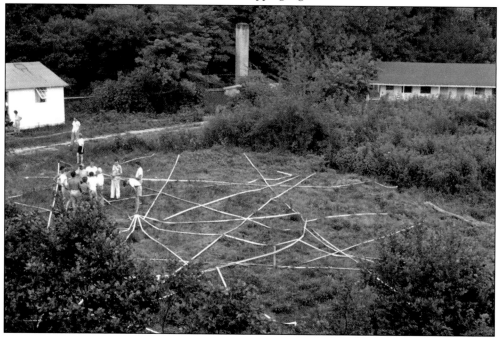

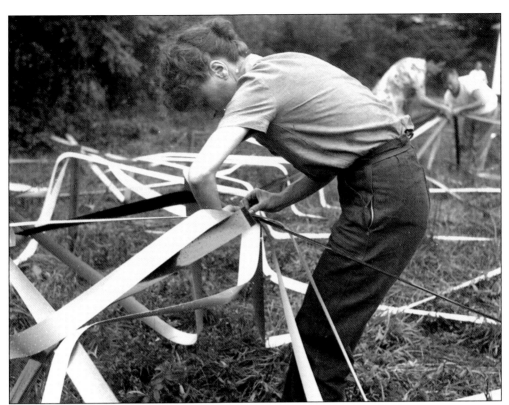

Though the first dome did not stand and, in fact, was not meant to stand by Fuller's own admission, the students in his class appeared to have a good time in the attempt. Above, Elaine de Kooning works on bolting together the venetian blind–strip dome during Buckminster Fuller's 1948 summer architecture class in this photograph by Trude Guermonprez. At right, photographer Masato Nakagawa captured Fuller's erect dome in the summer of 1949. It was first constructed in Chicago during the 1948–1949 academic year and then reconstructed at the college the next summer. From left to right are Jeffery Lindsay (in sunglasses), Joseph Manulik (behind Lindsay in the striped shirt), Ysidore Martinez (white T-shirt), and Louis Caviani (right foreground).

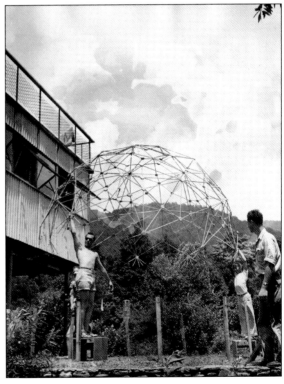

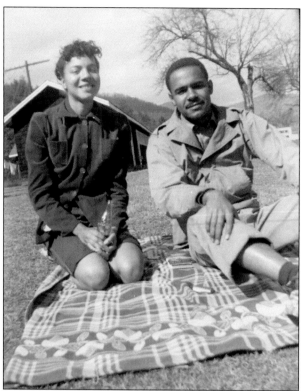

The question of race arose as early as 1933 at the college. After a long and heated community meeting, though it conflicted with the beliefs of many at the school, it was decided that a visiting African American student would be housed with a local family—as was custom at the time—rather than at the college itself. Black Mountain, as a fledgling school, erred on the side of caution in the early years. The first black community member was invited to stay for the 1944 Summer Institute. In the above photograph, Jeanne Belcher and Luther Jackson are pictured in the spring of 1947. They were part of the first wave of African American students accepted to the college as full-time students. Other African American students who attended the school include Sylvesta "Vesta" Martin, Louis Selders, Delores Fullman, Louise Cole, and Mary J. Parks. At right, instructors Jacob and Gwendolyn Lawrence (back left) pose with students on the steps of the dining hall.

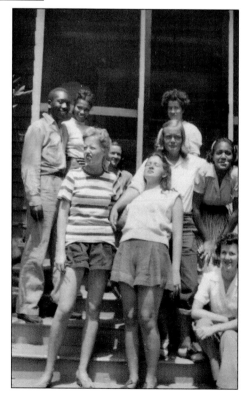

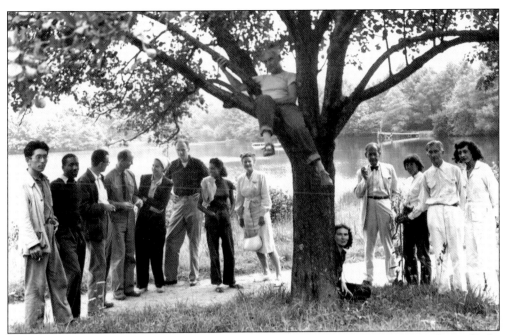

Pictured in this faculty portrait taken at the college's 1946 Summer Art Institute in front of Lake Eden are, from left to right, Leo Amino, Jacob Lawrence, Leo Lionni, Ted Dreier, Nora Lionni, Beaumont Newhall, Gwendolyn Lawrence, Ise Gropius, Jean Varda (in tree), Nancy Newhall (seated), Walter Gropius, Molly Gregory, Josef Albers, and Anni Albers.

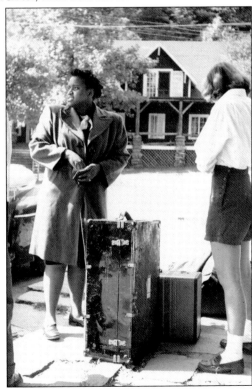

Dolores Fullman (in coat) stands outside the entrance to the dining hall. Fullman was a voice student of Johanna Jalowetz and also taught the jitterbug to other students at the school.

Tenor Roland Hayes taught at the 1945 Summer Institute. In this photograph, he is shown giving a public concert that was attended not only by the students and faculty at the college, but by the local community as well. After a successful concert, which had integrated seating and no problems, the school invited its first full-time black faculty member and black student.

Students and faculty lived, worked, and played together at Black Mountain College. This image shows a Saturday night dance in the Lake Eden dining hall in 1945. Pictured are Ralph Tyler (student in dark suit and glasses), Faith Murray (center, mid twirl), and the Lowinskys (couple seated at far right).

Students and faculty did not confine themselves to campus, but participated in community life around the area. Above, Theodore Dreier Jr. and Catharine Rondthaler (both in the back seat) are driven by M.C. Richards to Asheville in 1948 for an Easter Sing Fest at the Phyllis Wheatley Branch of the YWCA—a historically African American branch. Beside Richards in the front seat are Nicolas Muzenic and Peter Nemengi. At right, standing in front of the YMCA building are, from left to right, (first row) Ray Johnson, Charlie Dickson, and Ruth Asawa; (second row) Mervin Lane and Nicholas Muzenic.

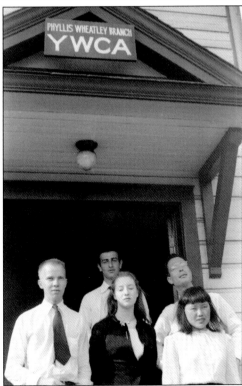

In the above photograph, student Ray Spillenger pulls away from Peek's Tavern in Roger Hewitt's car. For many years, students would frequent Roy's, a local beer house near the Black Mountain train station. But after locals complained about the students, one student, Stephen Forbes—who would go on to help with funding on many college projects—funded the construction of a roadhouse called Peek's Tavern outside of town. It quickly became a gathering place for discussion, drinks, and dancing for the college's students. Pictured at left from left to right, students Suska Dickson, Jerrold Levy, Felix Krowinski, and an unidentified classmate hang out in front of Peek's Tavern.

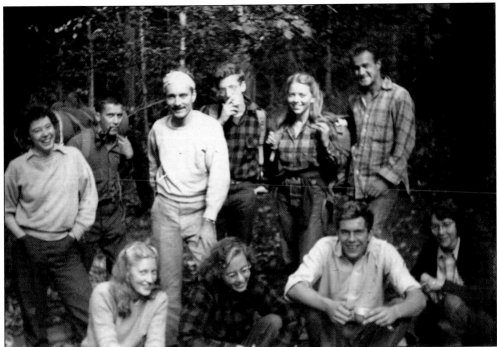

Hiking was a favorite activity of students. Above, a group of plaid-clad students goes for an overnight camping trip in the fall of 1948. They are, from left to right, (first row) Eine Sihvonen, Miriam "Mim" Sihvonen, Warren Outten, and Charlotte Robinson; (second row) Nancy Miller, Edward Adamy, Charles Boyce, Harry Weitzer, Katherine "Susie" Schauffler, and John Bergman. At right, a group hikes to the peak of one of the surrounding mountains to get a good view of the valley.

Faculty child John Corkran remembered of the informal sports program at the college that "football was oriented east-west [on the field just past the college's entrance]. Goal lines were line-of-sight, generally from a tree to some other landmark. There was a lot of trust, but occasional arguments. We played touch football, although the blocking was often full contact." In the Ilya Bolotowsky photograph above, the marching band plays before the start of the football game. Below, a crowd of students and faculty lines the sidelines of a football game at the college. Identified are student Susie Schauffler (standing, in black coat) and Prof. Bill Levi (far left, smoking pipe). This photograph was also taken by Ilya Bolotowsky.

There was no organized athletic program at the school, but pickup games were common. Student Martha Rittenhouse remembered, "There were sports at Black Mountain, but they were few and far between. Some of us played touch football for a few weeks until winter came. Usually the favorite sport was talking, or hiking." Here, students play touch football on Thanksgiving 1947. Student Stuart Atkinson remembers a game on Thanksgiving 1946 that was "an informal satire on college football." That particular game was between the Sticky Attitudes and the Cromagnons. The Cromagnons won 8-0.

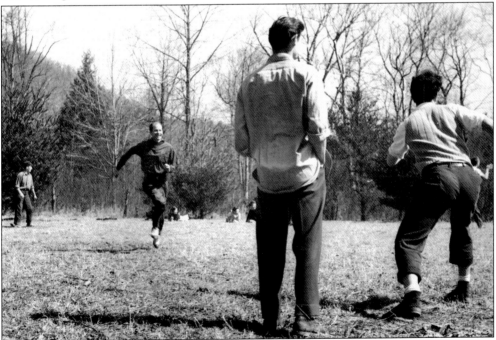

Here, Bill Levi runs to first base, where Mervin "Merv" Lane attempts to catch a ball. Neil Albright, coaching first base, watches the play. The field was oriented north to south, and foul lines were the sight lines between home and first and third bases. Bases were generally marked by a rock.

Students found countless ways to entertain themselves on campus. Those in the image at left are practicing gamboling, a form of tumbling. Student Richard Gothe stands in the back. Below, students have a snowball fight in the early 1940s. Student Jane Salter stands to the right of the snowman in this photograph by John Campbell.

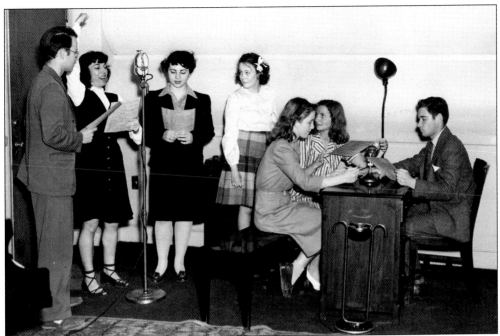

Faculty and students hosted weekly radio shows to help publicize the college. They would read announcements, act out performances, play music, and deliver addresses and prepared papers. The WNNC Asheville program director said they appreciated the effort of the campus to keep a listening audience week after week, as it was not easy to do. Here, students put on a radio show around 1941. Identified are Aurora Cassotta (raised hand) and Tonya Sprager at the microphone to the left."

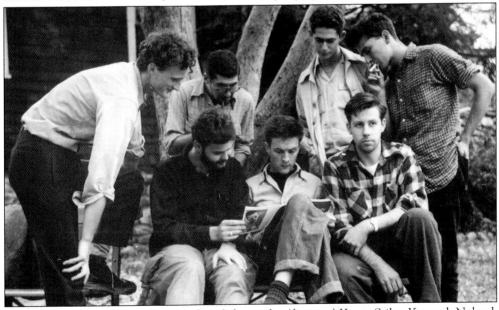

These students reading together are, from left to right, (first row) Knute Stiles, Kenneth Noland, and Stanley Hebel; (second row) "Slim," Leo Krikorian, Gregory Masurovsky, and Albert Brody. Kenneth Noland, an abstract painter, studied art with Josef Albers and Ilya Bolotosky at the college under the GI Bill.

Because most faculty members lived on the campus, their families were also ever present at the college, and young children were a part of campus life. Meadow's Inn, a cottage, was a faculty residence. The school added two apartments to the attic of the home and also insulated the house and installed a heating system. In 1948, both the Corkran and Rondthaler families lived in the cottage. Identified in the photograph is Robin Corkran (far right). The others are thought to be Rondthaler children.

Prof. Richard Lippold and his family drove a hearse. Pictured here are two of his children, Lisa and Tiana, in the hearse during the 1948 summer session in the arts. Lippold came to the college in the summer of 1948 to teach a sculpture class.

The Moles family, who were Quakers, came to the school in 1946. Cliff was one of the college farmers. He left in September 1948 after conflicts arose between him and the other farmer, Ray Trayer. His wife, Shirley, kept their children. Above, Shirley Moles and her daughter Diane are pictured with their dog, Blackie, in July 1946 at the Woods Cottage, where they lived for a short time. The Woods Cottage, which was also known as the New Cottage, was designed by Josef Albers and built in the spring of 1939 by local workers. Pictured at right in July 1948, Cliff Moles and his son Denis sit outside the farmhouse where they later lived at the college.

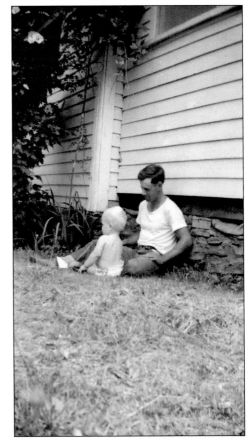

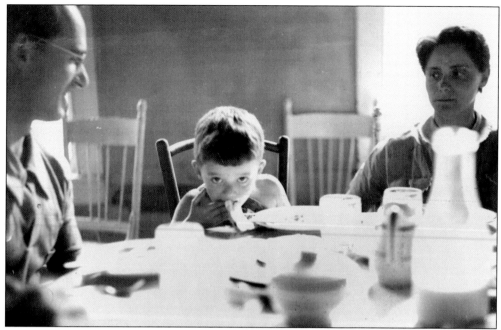

Nathan Rosen and his family have breakfast at Lake Eden. Rosen studied at the Massachusetts Institute of Technology and was an assistant and collaborator with Albert Einstein, who was on the advisory council for the college. Rosen taught physics at Black Mountain from 1940 to 1941 and then returned for the summer session in 1949.

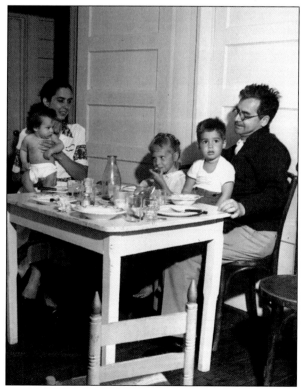

In this photograph by Joseph Breitenbach, Jean Charlot and his wife, Dorothy Zohmah Day, have dinner with their children in the kitchen at Black Dwarf. Children Ann Maria and John Pierre sit on Jean Charlot's lap. Martin Day, born in 1944, sits with his mother. Black Dwarf was a home already built when the college relocated to Lake Eden. It was remodeled to add extra bedrooms and bathrooms. The college had tried to recruit Jean Charlot to teach at the college in 1939, but his schedule only allowed him to come teach during the summer of 1944. He painted the two frescoes on the pylons under the Studies Building.

Five

THE END AND THE BEGINNING

With the departure of Dreier and the Alberses in 1949, the Black Mountain College of the 1950s was a different place. If John Andrew Rice had led the college in the 1930s, and Albers and Dreier in the 1940s, then Charles Olson was the central figure at the college in the 1950s. He came to teach writing and literature in 1948 and became rector in 1953. It was during this time that the college began to emphasize writing as an art form. In the photograph, Charles Olson and his second wife (and student), Betty Kaiser, sit outside the Jalowetz house. Olson and his family moved into the house in 1953 after Johanna Jalowetz left the college.

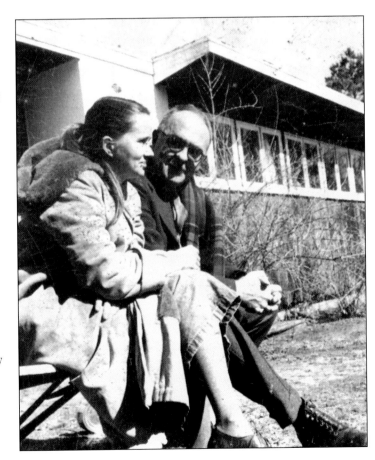

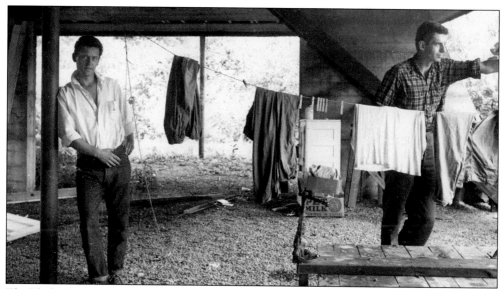

The Black Mountain poets were a group of postmodern poets associated with the college beginning in the 1950s, though many of the Black Mountain poets never set foot on campus. In the above portrait taken by Jonathan Williams, Dan Rice (left) and Robert Creeley (right) pose under the Studies Building about 1955. Robert Creeley, who taught literature and writing in 1954 and edited and published the *Black Mountain Review* for two years, was one of these poets, as was Charles Olson. Rice was a student from 1946 until 1953. Below, in a 1956 Jonathan Williams portrait, is Robert Duncan, another writer associated with the Black Mountain poets, who taught at the college in 1956. It was Duncan who, at the end of the college's life, would help many displaced Black Mountain students and faculty find a new home in San Francisco's Renaissance movement.

Jonathan Williams was another of the Black Mountain poets. He was also known as an essayist, photographer, and publisher. He founded the *Jargon Society* while at the college in 1951 to publish obscure writers. His press published many of Black Mountain's writers, including Charles Olson, Lou Harrison, and Joel Oppenheimer. The above portrait was taken of Jonathan Williams at the college. Lou Harrison, pictured below, was a composer who taught at the college in 1951 and 1952. Harrison came to Black Mountain from New York City, where he had worked with John Cage, who recommended him to come teach at the school to get away from the stress of the city. It was at Black Mountain, inspired by his surroundings, that Harrison began experimenting with Asian music and sounds.

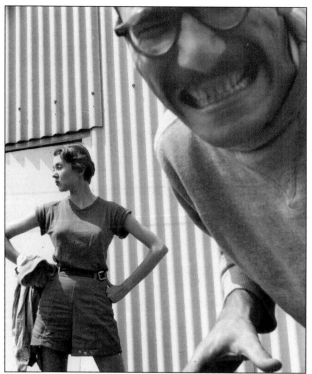

At left, in a 1951 Jonathan Williams portrait titled *Beauty and the Beast*, Joel Oppenheimer grins in the foreground, while Francine du Plessix Gray strikes a pose in the background. Oppenheimer was another of the Black Mountain poets. He came to the school as a student in 1950 and took courses with Charles Olson and Paul Goodman, and he became good friends with Fielding Dawson and Ed Dorn, other student writers at the college. He worked at the college print shop and married another student, Rena Furlong. Francine Du Plessix Gray studied at Black Mountain in the summers of 1951 and 1952. She would go on to become a Pulitzer Prize–nominated writer. Below, writer Alfred Kazin works at his typewriter in the Studies Building.

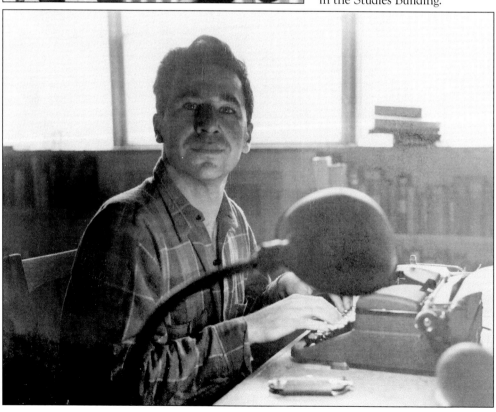

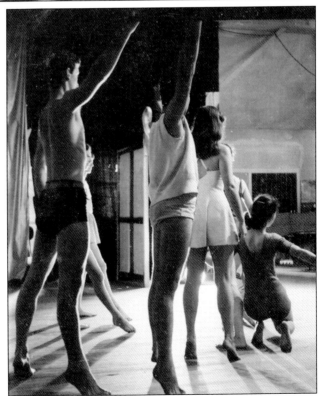

Above, American composer
John Cage (left) and
choreographer Merce
Cunningham visit Ruth R.
Julian at her home in Winston
Salem, North Carolina, on a
trip to New York from Black
Mountain College in 1953.
Cage taught at Black Mountain
College in the summers of
1948, 1952, and 1953 and staged
the first "happening" at the
college, a loosely structured
mixed-media, theatrical event
in which he read a lecture
with long spaces of silence and
asked Charles Olson and M.C.
Richards to read poetry, Robert
Rauschenburg to display his
paintings, David Tudor to play
piano, and Merce Cunningham
to dance. Cunningham founded
the Merce Cunningham Dance
Company at the college in 1953.
At right, Merce Cunningham
performs with his dance class in
the dining hall at Lake Eden.

Musician David Tudor taught and was the pianist in residence at the college beginning in 1951. The idea for the first "happening" at Black Mountain arose during a discussion between John Cage and Tudor. Cage recalled in a conversation with author Martin Duberman, "Our ideas were so electric at that time that once the idea hit my head—and I would like to give David Tudor equal credit for it—I immediately then implemented it." Around the same time, accomplished dancer Katharine Litz, pictured below in a 1950 portrait by Jonathan Williams, came to teach modern dance.

In 1948, Robert Rauschenberg and his future wife, Susan Weil, who were studying in Paris at the time, decided to attend Black Mountain College. Rauschenberg, a painter and graphic artist, worked with Josef Albers, though he remembered that he would often do "exactly the reverse" of what Albers taught him. He is pictured at right in about 1949 on the deck of the Studies Building with Svarc Lauterstein, who is wearing a centaur costume designed by Rauschenberg as a Mardi Gras costume for his sister. Below are Susan Weil and Rauschenberg on campus in 1949. Weil also studied under Albers and was best known for her three-dimensional, mixed-media paintings.

Painter Edwin Parker "Cy" Twombly Jr. met Robert Rauschenberg in New York in 1950. Rauschenberg encouraged Twombly to attend Black Mountain College. He studied at the college in 1951 and 1952 under Ben Shahn, Robert Motherwell, and Franz Kline. Several of his works are now on permanent display at the Museum of Modern Art in New York and at the Louvre in Paris. This photograph of Twombly was attached to his application for admission to the college.

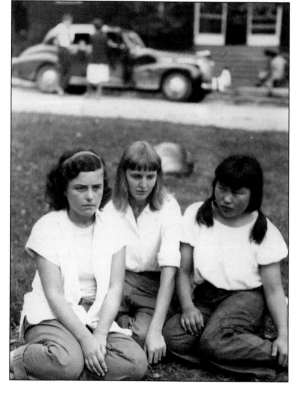

Sculptor Ruth Asawa was a student at the college from 1946 until 1949. She studied under Josef Albers, with whom she learned to make art from commonplace objects and gained the confidence to pursue art as a career. Asawa also met her future husband, architecture student Albert Lanier, at the school. In this photograph, Elaine Schmitt Urbain (far left) and Ruth Asawa (far right), who were best friends even before studying together at Black Mountain, sit on the lawn behind the dining hall with an unidentified girl.

In 1949, the college decided to start a pottery program and invited potter Robert Turner to set up a shop near the Studies Building. Prior to 1949, ceramics courses were not offered, as Josef Albers felt clay would not be a good medium for beginning students. Turner, with the help of Paul Williams and student labor, designed and built the Pot Shop from 1949 to 1950. After Turner left in 1951, the college invited Karen Karnes and David Weinrib—pictured above in this photograph by Edward DuPuy in front of the Pot Shop—to teach. In 1953, the one-person shop was expanded by Jack Rice. At right, the 1952 pottery seminar instructors are pictured in a William Watson photograph. From left to right are Shoji Hamada, Bernard Leach, Soetsu Yanagi, and Marguerite Wildenhain. Karnes remembered of the seminar, "Watching Hamada work was the most important ceramic instruction I, as a young potter, could have . . . I learned . . . just accept the clay and the wheel as they are and do the best you can with what you have."

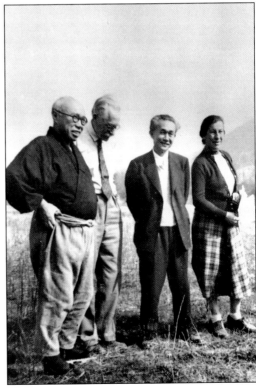

With the college still struggling financially, Charles Olson decided to lease the lower portion of the campus to a Christian boys' camp in 1956. Camp Rockmont, which still operates at Lake Eden, would go on to purchase the entire property. In this Lorna Blaine Howard photograph, an unidentified man holds the Black Mountain College sign under the Camp Rockmont for Boys sign at the beginning of Lake Eden Road.

Charles Olson is seen writing in this Jonathan Williams portrait. Olson and his family stayed at the college through the end of 1956 and into 1957 to deal with all the matters of closing the college—selling the real estate, distributing the library, and ensuring the graves of Jalowetz and Dehn would be maintained, among many other things.

Mr. and Mrs. Ted Drier February 22, 1956
2121 Union Street
Schenectady, N.Y.

My dear Ted and Bobbie:

 Your new address came to my hand today, and I make use of it to write you what the Board has wanted me to write you, for some time.

 As you may have heard, during the past year we have had the oportunity to lease (with an option to buy) what have come to be called the "Down Acres", that is, 200 acres, including the lake, the dining hall, the two lodges, Brown and Stone Cottages, etc. down to the Rhodes property.

 We sought, from the start, to have the Quiet House and environs created as a unit of itself, to try to keep it so far as possible as you might have wanted it, and, though the property was passing to other hands, to insure, if we could, that that part of it continue to be dedicated to its purpose.

 We were not able to get it left out of the contract, simply that the leasor, George Pickering, former director of the Camp Ridgecrest Camp for Boys, planned to use the ridge above and the V to the Quiet House's side for a main part of his Senior Boy's activities. But he was wholly responsive to our concern and promised us that the Quiet House would be used as his religious center. (As you may know, Ridgecrest is Baptist, and Pickering's new camp for boys here - Camp Rockmont - will, I dare say, be as concernedly run as he ran the Ridgecrest Camp.)

 We deeply regret that we had to part with the Quiet House yet we hope you will believe that both the leasor and his plans for it are the very best one might hope for, under the circumstances.

 Please let us know if there is anything you might like us to do which we might not know of that might be of personal importance to you as of that part of the property. It remains, of course, the College's until the option to purchase is taken up, but Mr Pickering has gone ahead with improvements as such a rate that one can assume he will purchase.

 For all of us, and for myself personally to you both, our concern that this change, painful as it surely must be, be accepted by you as one of those things which could not be helped but which, because of Mr. Pickering, is the best it might be.

 Affectionately yrs,

 Charles Olson

In this 1956 letter from Charles Olson to the Dreiers, Olson assures them that, despite having to lease (and eventually sell) the lower portion of the property, the Quiet House, which was built as a memorial to their deceased nine-year-old son, would be maintained by the new owners as a "religious center." The camp added a second story to the Quiet House, which is now used as a residence.

Lake Eden
Black Mountain, North Carolina

BLACK MOUNTAIN COLLEGE REUNION
October 28, 1995

The Black Mountain College Museum and Arts Center in Asheville sponsored a reunion of former Black Mountain College faculty, students, and their relatives on October 27–29, 1995. Each participant was asked to submit an 18-by-24-inch panel of art, letters, photographs, essays, and/

or other materials relating to their remembrances of the college for an exhibition at the center. Over 100 panels were submitted. This photograph of the reunion was taken on October 28, 1995, at Lake Eden. (Courtesy of Benjamin Porter.)

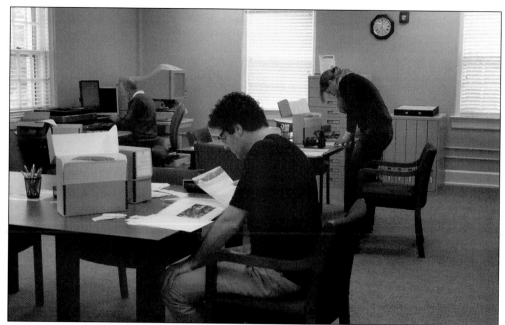

Black Mountain College continues to be a topic of interest for artists, educators, historians, and even novelists. Conferences, publications, presentations, exhibitions, and countless other events related to the college happen worldwide every year. In 2013, well-known author Nicholas Sparks released a novel, *The Longest Ride,* which will be made into a movie in 2015 and features Black Mountain College. Above, University of San Francisco associate professor and Black Mountain College researcher David Silver uses the Western Regional Archives to research the college farm, graduate student Astrid Kaemmerling researches integration at the college, and volunteer Phil Lane scans images. Below, David Silver leads a tour of the farm on the Lake Eden campus in 2013. (Courtesy of Heather South.)

Put on annually by the Black Mountain College Museum and Arts Center, "The {Re}HAPPENING honors the dynamic artistic energy of Black Mountain College and pays tribute to the groundbreaking innovations of that community of artists. Meanwhile, the event launches a contemporary platform for artists and patrons to experience adventurous art and creativity in the present day." The event takes place on the Lake Eden campus for one evening each spring and features dozens of experimental artists from around the region. Art installations, theater, music, and poetry "happen" throughout the entire lower campus, creating an immersive experience for guests. Above, {Re}HAPPENING guests gather for dinner in the Lake Eden dining hall in 2013. Below, two artists perform inside an art installation during the 2013 {Re}HAPPENING. (Both, courtesy of David Silver.)

BIBLIOGRAPHY

www.blackmountaincollegeproject.org

Dawson, Fielding. *The Black Mountain Book*. Rocky Mount, NC: North Carolina Wesleyan College Press, 1991.

Duberman, Martin. *Black Mountain College: An Exploration in Community*. New York: E.P. Dutton & Co., 1972.

Harris, Mary Emma. *The Arts at Black Mountain College*. Cambridge, MA: MIT Press, 1987.

Katz, Vincent, ed. *Black Mountain College: Experiment in Art*. Cambridge, MA: MIT Press, 2002.

Lane, Mervin, ed. *Black Mountain College, Sprouted Seeds: An Anthology of Personal Accounts*, Knoxville, TN: The University of Tennessee Press, 1990.

ABOUT THE ORGANIZATIONS

THE WESTERN REGIONAL ARCHIVES

The Western Regional Archives (WRA), the western headquarters for the State Archives of North Carolina, opened in August 2013. Located in the newly restored former Veteran's Administration Hospital minority nurses' dormitory in Asheville, the WRA continues to work to fulfill its mission of collecting, preserving, and making accessible the documentary heritage of the western region of North Carolina. Through ongoing collection acquisition, a public search room, and continued outreach and education programs, the WRA is becoming a well-known hub for archival research and preservation information.

The Black Mountain College materials, the Blue Ridge Parkway construction photographs, and a ciphering text from 1828 are just some of the collections currently available at the facility that attracts scholars from around the world to the Asheville location. The archives are full of documentary treasures that are waiting to be discovered. Western North Carolina is known for its mountains, and at the Western Regional Archives, history has a view.

SWANNANOA VALLEY MUSEUM

In 1989, a group of local citizens founded the Swannanoa Valley Museum. Their goal was to acknowledge and preserve the contributions of past generations, creating a collection that vividly depicts the history, culture, and character of the valley. Today, the museum is recognized as the primary museum of general, local history in Buncombe County.

Inside the museum's historic building, which was designed in the 1920s by the supervising architect on the Biltmore Estate, Richard Sharp Smith, gallery exhibits include both artifacts and pictorial displays. The museum also manages a large collection of original photographs and maintains a local library and vertical files to aid local history researchers.

The Swannanoa Valley Museum offers a variety of event programs off site—including guided tours of historic homes and the former campuses of world-famous Black Mountain College. The museum's hiking program covers some of the area's highest, most-historic, and most-rugged terrain.

DISCOVER THOUSANDS OF LOCAL HISTORY BOOKS
FEATURING MILLIONS OF VINTAGE IMAGES

Arcadia Publishing, the leading local history publisher in the United States, is committed to making history accessible and meaningful through publishing books that celebrate and preserve the heritage of America's people and places.

Find more books like this at
www.arcadiapublishing.com

Search for your hometown history, your old stomping grounds, and even your favorite sports team.